DRAWING GALLERY

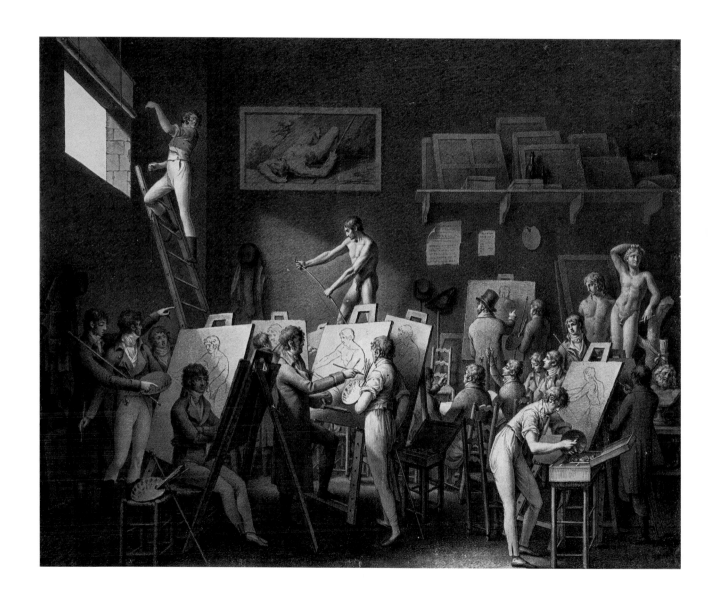

LOUVRE

DRAWING GALLERY

Gérard, Girodet, Gros
David's Studio

Arlette Sérullaz

5

CONTINENTS

Cover
A.-J. Gros, *Alexander Breaking in Bucephalus*
(pl. 41).

Frontispiece
J.-H. Cless, *David's Studio*, Paris,
Musée Carnavalet.

© Musée du Louvre, Paris, 2005
© 5 Continents Editions srl, Milan, 2005

http://www.louvre.fr
info@5continentseditions.com

ISBN Musée du Louvre: 2-35031-027-2
ISBN 5 Continents Editions: 88-7439-253-2

For the Musée du Louvre:

Editorial Coordinator
Violaine Bouvet-Lanselle

Iconography
Christine André
Isabelle Calvi

Acknowledgements
Caroline Coujard de la Planche,
Régine Dupichaud, Marielle Dupont,
Laurence Lhinarès, Mathias Petit,
Ludwig Speter, Christine Veauvy

For 5 Continents Editions:

Editorial Coordinator
Paola Gallerani

Translation
Susan Wise

Editing
Fronia W. Simpson

Art Director
Fayçal Zaouali

Layout
Marina Longo, Virginia Maccagno

The exhibition "David's Studio" has benefited
from generosity of Mrs. Charles Wrightsman.

The paper for this publication
has been kindly offered by

TABLE OF CONTENTS

"I CANNOT TELL YOU HOW DELIGHTED I WAS BY M. DAVID'S LETTER [...]. FORTUNATE IS THE MAN WHO CAN RECEIVE AND APPRECIATE THE ADVICE OF A MAN SUCH AS HIM!" *

Arlette Sérullaz

Because the teaching Jacques-Louis David imparted in his studio was based on the study of antiquity—"which has always been the greatest school for modern painters"—and on the imitation of the Old Masters—"in the *genius of their drawing*, the expression of their figures and the gracefulness of their forms"—it soon became synonymous with sectarian indoctrination. "Take and cast into prison the most ordinary fellow in the world, the least familiar with the slightest notion of art and literature, in a word one of those ignorant idlers who throng a great capital, and once he has overcome his first fright, tell him he will be set free if he succeeds in exhibiting at the Salon a nude figure, perfectly drawn according to David's system, and you will be surprised to see the captive you thus put to the test back in society in less than two or three years", Stendhal sarcastically claimed in his review of the Salon of 1824. "That is because accurate, studied drawing, imitated from the antique, as David's school understands it, is an exact science, of the same nature as arithmetic, geometry, trigonometry, etc., which means that with endless patience and Barême's brilliant genius, in two or three years you can learn and as a result reproduce with a brush the structure and exact position of the hundred or so muscles covering the human body. During the thirty years that

David's tyrannical rule lasted, the public was made to believe, at the risk of being accused of bad taste, that having the patience needed to acquire the *exact science* of drawing implied having genius" (STENDHAL, 1972, pp. 25–26). In our time David's school has not really been popular with the public, doubtless because the mind-set that condemned the master for fathering academicism and the pupils for letting themselves be shackled to his dictates is still too entrenched. Yet, already some time ago (in 1867, did A. Jal not announce that David would regain his popularity?), art historians began to revise this biased judgement (research by Kl. Holma, in 1940, and L. Hautecoeur, in 1954, set the wheels in motion). Demonstrating, with many sound arguments, that David is not the monolithic figure some critics describe, scholars began to recall, among other things, that Romantics such as Delacroix recognised the greatness of David's work. "David is a singular composite of realism and ideal", Delacroix noted in his *Journal* at the end of his life, on 22 February 1860 (p. 767): "He was the father of the entire modern school in painting and in sculpture [...]. He replaced the bastardised and Pompadour style with Herculaneum and Pompeii, and his principles were so influential that his school was not inferior to him and produced some pupils who equalled him.

* F.-J. Navez to A.-D. De Hemptinne, March 1818; ALVIN, 1870, pp. 91–93. 6

He still rules in some ways, and despite a few apparent changes in the taste of today's school, it is obvious that everything still derives from him and his principles." More recently, on the occasion of the symposium held during the David exhibition at the Musée du Louvre for the bicentennial of the French Revolution, Thomas Crow insisted on the strong ties which, overlooking tensions that are unavoidable in such situations, united the community of young artists and David, believing that David's role was largely that of generating the atmosphere of empathy that prevailed in his studio: "As soon as he became his own master, his studio was remarkable for the close cooperation and outstanding quality of the intercourse between pupils and professor, to the extent that he ended up relying to a great degree on the ideas and abilities of his disciples" (CROW, 1989, p. 845).

Let us not be misunderstood: it is not our intention here to reopen the discussion, nor even less to seek to provide it with new arguments. The context of this book scarcely lends itself to that aim, especially since, despite the wealth of the Graphic Arts Department, several of David's pupils—and some of the most gifted—are scantily or poorly represented here. That is the case of Drouais, whose graphic work is mostly conserved in the Musée des Beaux-Arts in Rennes, or of Wicar, whom we must go to Lille or Italy to study. Furthermore, one of David's most famous pupils, Jean-Auguste-Dominique Ingres, does not figure in our selection since an earlier book in this series has already been devoted to him. Still, we hope to encourage an examination, without preconceptions, of drawings which offer proof in themselves that the movement called Neoclassicism was a decisive phase, one of the most productive and tumultuous, in European sensibility.

If we content ourselves with a chronological inventory of the drawings that have entered the Louvre collections over the past two centuries, one thing is clear: most of the sheets reproduced in this book entered in the nineteenth century. After the purchase, in all likelihood under comte de Forbin's directorship, of a study by Drouais for the painting with which he won the Prix de Rome, *The Woman of Canaan at the Feet of Christ* (pl. 1), the museum administration carefully followed the sales held after the deaths of David's principal pupils who had won official recognition during their lifetime. At the Gros sale (23 November 1835), for example, it purchased a drawing directly linked to the painting for the new sacristy of the Abbey of Saint-Denis and which was removed to the Louvre in 1820, *Francis I and Charles V at the Abbey*

of *Saint-Denis* (pl. 45). By the same token, *The 10th of August 1792* by Gérard (pl. 5) was purchased at his estate sale in April 1837. The Louvre also received donations from the close circles of these same artists: *The Death of Timophanes* by Gros (pl. 40) was bequeathed by his widow in 1842, the *Portrait of Firmin Didot* by Girodet was given in 1848 by the sitter's family (pl. 38), whereas the study for *The Battle of Nazareth* by Gros (pl. 42) was offered by one of his pupils, Auguste-Hyacinthe Debay, in December 1851. In 1860 Pierre-Charles-François Delorme, a pupil of Girodet, donated the *Half-length Portrait of Canova, in Left Profile* by the latter (pl. 39). In passing we should point out that up to the end of the nineteenth century visitors going through the rooms on the first and second floors of the Louvre, which were devoted to drawings, could see the portraits of Firmin Didot and Canova by Girodet, as well as the three drawings by Gros linked to the paintings hung close by, *Napoleon in the Pesthouse at Jaffa* and *Francis I and Charles V at the Abbey of Saint-Denis*. As for the drawing François Cacault commissioned from Jean-Baptiste Wicar to commemorate the Concordat, *Pope Pius VII Handing over to Cardinal Consalvi the Ratification of the Concordat Signed in Rome between France and the Holy See* (pl. 50), given to Bonaparte by the papal legate in 1803, it entered the Louvre and was transferred to Versailles before 1855. At the sale of Alexandre-Pierre-François Robert-Dumesnil (1778–1864), who gave up a notary's career to devote himself to his passion for prints and drawings and to write the eight volumes of the *Peintre-graveur français* (Paris, 7–9 April 1845), the Louvre purchased a score of drawings of every school and period, including three drawings by Fabre (pl. 2). Last, in 1878, Eugène Oudinot offered the Louvre a second study by Gros for *Francis I and Charles V in Front of the Abbey of Saint-Denis* (pl. 44), but this time featuring a version different from the one finally executed. Later, the strange *Judgement of Midas* imagined by Girodet (pl. 31) was purchased at the sale of his great-nephew, Paul Becquerel, on 17 February 1922. A series of gifts, in the same period, confirms that there was still interest in David's pupils. In 1836 two drawings by Hennequin were donated by the painter Auguste Couder (pl. 47): they are in fact the only two works by this extravagant, bizarre artist conserved in the Graphic Arts Department. In 1851 Frédéric Reiset was allowed to choose no fewer than twenty drawings by Gérard, on the generous invitation of the painter's nephew, Baron Henri-Alexandre Gérard (1818–1903), author of several books devoted to the work of his uncle (1852–1857) and his correspondence (1867). In 1866 the Widow Luillier offered three Girodet drawings including a pastel study linked to the *Revolt at Cairo* (pl. 32). In 1895 one of the first sketches by Gros for *Napoleon in the Pesthouse at Jaffa* (pl. 43), once owned by the chief surgeon of the army of Egypt, Baron Jean-Dominique Larrey, then by his son, Hippolyte, was donated to the Louvre by the latter's general legatee, Juliette Dodu.

In the first quarter of the past century, aside from the bequest in 1911 by Mlle Daria A. Pomme de Mirimonde of four drawings by Girodet including two studies for *The Entombment of Atala* (pl. 30), or the gift in 1917 from Georges Montfort of three Girodet drawings including another study for the *Revolt at Cairo* (pl. 33), additions to the Neoclassical collection ceased. Probably because tastes had changed, David's pupils were no longer in vogue. We have to wait until the 1970s, a decade marked by several important exhibitions—in Paris, at the Louvre, in 1972, "French

Drawings from 1750 to 1825 in the Collections of the Musée du Louvre", "Neo-Classicism" in London, at the Royal Academy, in the Fall of the same year, "The Age of Neoclassicism" (organised by the Conseil de l'Europe), in Paris at the Galeries nationales du Grand Palais, in 1974 "French Neoclassicism: Drawings from Provincial Museums" (concurrently with the exhibition "From David to Delacroix")—for interest on the part of scholars and art lovers in David's school to be revived. In 1970 came the purchase, through the auspices of his granddaughter, of thirty-nine drawings which had belonged to Émile-Louis Calando (1840–1898). Among them were eleven drawings by Girodet, including a scene inspired by the novel by Longus, *Daphnis and Chloe* (pl. 29), and three studies for *Orpheus Embracing Eurydice*, subsequently attributed to Gérard (pls. 6–8), as well as a small—but not negligible—sheet by Gros, *Alexander Breaking in Bucephalus* (pl. 41). Even more significant in this respect is the acquisition in 1972 of 171 drawings by Gérard which had remained in the possession of the painter's descendants and never published. The group, including portraits, landscapes, and copies after the antique, as well as preparatory studies for his principal paintings, provides precious information on the method Gérard used to prepare, meticulously but not without some rethinking, his large compositions: history subjects, such as *The Entry of Henry IV into Paris* (pl. 13), allegorical, notably a set of drawings for the pendentives of the dome of the Pantheon (pls. 14–19) and a group of studies for the huge painting he left uncompleted at his death, *Achilles Vowing to Avenge the Death of Patroclus* (pls. 20, 22, 25–27). In 1996 the donation, subject to usufruct, of Louis-Antoine and Véronique Prat included two drawings by Gros, *Arab beside His Wounded Horse* (Inv. RF 44 333), and *Head of a Man in Left Profile* (Inv. RF 44 332). Originally this second drawing belonged to an album containing copies by Gros after the Old Masters as well as studies for various paintings. Either a mere coincidence or a carefully thought-out gesture, in 2000 M. and Madame Raymond Poussard offered a drawing from the same album (pl. 46).

The artists who came from every part of Europe to work in David's studio did not escape the ostracism that stigmatised his French pupils. To be honest, the purgatory of the foreign artists lasted even longer. Let us take, for instance, David's Belgian pupils, Joseph-Denis Odevaere and François-Joseph Navez, in particular, who welcomed their master with the most gracious kindness when David, who was sentenced to exile as a regicide after the return of Louis XVIII and also because he had signed "the additional act or accepted functions or employment of the usurper", decided to settle in Brussels (27 January 1816). A group of Belgian historians (D. Coekelberghs, A. Jacobs and P. Loze) in the 1980s organised several exhibitions and their accompanying publications on the subject of Neoclassicism in Belgium and more particularly on David's Belgian pupils. The painted and drawn work of these artists began to resurface—cautiously—on the Parisian art market. In 1994 the Louvre decided to purchase its first drawing by Navez (pl. 49) and bought a second one nine years later, when a composition by the same artist was proposed. *The Deploration of Christ* (pl. 48), held in private hands and never shown, is as striking in its format as in its subject. This purchase enhanced a section of the collection that had hitherto been entirely neglected with an unquestionable masterpiece. Just recently the Louvre focused its attention on Girodet once again. Following a long-standing tradition, aiming to preserve

albums or reassembled collections in their entirety, and—why deny it, in view of the exhibition planned at the Louvre for the Fall of 2005—early this year the Graphic Arts Department, with the backing of the CCF group, which has constantly supported its policy of collection enrichment over the past few years, purchased a group of drawings and poems collected in a book and relating to Girodet's project, which remained uncompleted, to produce an edition of Anacreon's *Odes* (pl. 37) at his own expense. This collection, admirably bound by a Parisian craftsman of German birth, once belonged to the great bibliophile Henri Beraldi.

To the young artists who benefitted by his teaching, David recommended seeing "nature through the antique without altering the individuality of the different live models subject to [their] investigations." Jean-Germain Drouais (1763–1788), François-Xavier Fabre (1766–1847), François Gérard (1770–1837), Anne-Louis Girodet (1767–1824), Jean-Antoine Gros (1771–1835), Philippe-Auguste Hennequin (1763–1833), Jean-Baptiste Wicar (1762–1834) and the Belgian François-Joseph Navez (1787–1869), since they are the ones in question, learned to temper their graphic style, privilege the pencil or pen line that outlines contours and defines form, express volumes by spreading light and shade evenly without striving for contrasts. Drouais and Hennequin entered David's studio in 1781. That very year he was admitted to the Academy with *Belisarius Asking for Alms* (Lille, Musée des Beaux-Arts) and authorised to exhibit at the Salon. In 1782 came Wicar's turn, joined by Fabre in 1783, just when David presented at the Academy *Andromache Mourning Hector* (Paris, Musée du Louvre). Early in 1784, Girodet informs his mother he is working in David's studio. In the Fall he enters Brenet's, while Drouais and Wicar accompanied David when he decided to travel to Rome to execute the painting commissioned by King Louis XVI: *The Oath of the Horatii* (Paris, Musée du Louvre). At their master's side, they roamed the Eternal City (especially Drouais), copying everything they could see in the palaces, the galleries, the museums and the churches (paintings by the Old Masters, antique statues and bas-reliefs), thus creating for themselves a repertory of forms and motifs which would lastingly anchor them in the orthodoxy of the return to antiquity. When David returned to Paris in the Autumn of 1785, Gros knocked on the door of his studio. Until the Revolution and even later, they all saw David occupied with the works in which he imposed the lessons of antiquity on history painting. Pupils had to draw for a long time before being allowed to paint: thus cursive drawing, contour drawing, was raised to the dignity of an institution (it will be the basis of the instruction of the École des Beaux-Arts, which was reorganised in 1795), but it varied widely with the personality of those who applied it. It could be strict and conscientious or else encourage individual flights of fancy. In some cases it even gave rise to works that expressed, more or less openly, an underlying dualism in which impulse went hand in hand with intellect.

After Drouais's death, Gros was David's favourite pupil. When his master was forced into exile, Gros was put in charge of the studio. Giving free rein to his inclination for energy and drama, already latent in a drawing like *The Death of Timophanes* (pl. 40), in 1815 he began giving out advice quite contrary to David's theories: "Nature is not to be copied. It is to be interpreted and not everyone is able to", or else: "You should proceed by ensembles; ensemble of movements, of lengths, of light and shadow, ensemble

of effects. You should not […] treat a portion without seeing the whole: are you doing the head? Look at the feet, and so on" (Delestre, 1845, p. 483). But in Brussels David was on guard. "I am very touched by the marks of friendship you have constantly given me", he wrote on 27 July 1816, "I appreciate them, but do put an end to them as regards me personally or, better said, apply the qualities of your heart and your gratitude toward me to my beloved pupils whom you are instructing […]. Preserve them, be their guide. They can only be led by virtue and talent" (Wildenstein, 1973, no. 1791). Worried on seeing Gros continue to treat contemporary subjects—on commission, it is true—he exhorted him to read some Plutarch so as to prepare for a large history painting: "You love your art too much to be content with *futile subjects*, occasional paintings" (letter of 22 June 1820, Wildenstein, 1973, no. 1877). Shortly thereafter, appointed to the professorship at the École des Beaux-Arts, Gros felt more committed than ever to defend the cause of classicism but, torn between fidelity to his master's teachings and his own Romantic aspirations, he was unable to overcome his dilemma. His late paintings reflect this, whereas his pen drawings retain a violence which was no longer indebted to classicism: as soon as the artist became the eulogist of the Napoleonic epic (pls. 42, 43), his stroke became swifter, more spirited, his ardent sensibility was expressed in broken, zigzag, spasmodic lines (pl. 41). Marked by the "Anguished transition from the immobility of David to the tumult of Delacroix" (Faure, 1948, p. 208), gifted with an impulsive temperament, Gros showed the way to the fiery, ardent drawing of Delacroix.

Early in his career Gérard proved himself a scrupulous pupil of David, apparently the most faithful of all, especially when, like his master, he treated classical subjects or interpreted an episode of the Revolution (pl. 5), borrowing for his own the composition of David's large paintings and even the postures of his figures. More than Gros, Gérard showed an obvious predilection for the graphite pencil, which he wielded with assiduity: wishing to preserve the image of his paintings, it was the medium he used to put their essential features on paper (pls. 3, 4). Yet for all that, the artist did not give up the vibrant accents of the black pencil or the softness of stump when he was striving to evoke the misty atmosphere of Ossianic subjects (pls. 9–11) or to compose dramatic scenes, corresponding to a complex decorative programme. Thus in the studies for the pendentives of the Pantheon (pls. 14–19), the search for effect outweighs the care given to the figures, while the overlaid lines reveal his efforts to find the right composition required by the shape of the pendentives. Testimony of the interminable elaboration necessary for an ambitious work, *Achilles and Patroclus*, laboured over for almost twenty-seven years with interruptions and finally not completed, the drawings linked to the overall composition or to one or another group of figures reveal the painstaking progress of a thought that began with a very sketchy placing of the forms and a search for the general idea (pls. 20–28). A few figures were developed in several consecutive drawings (pl. 22), while others stand out for the expressiveness of the faces (pl. 24) we have already seen in the sequence of the three studies for *Orpheus Embracing Eurydice* (pls. 6–8). Poised between Neoclassicism and Romanticism, Gérard's drawn oeuvre, like his painted work, presents a certain ambivalence and a complexity which actually enhance it. Gérard was also in his own way a harbin-

ger of what would become French Romanticism, where at times passion was tempered by reason.

Among David's principal pupils, Girodet was unquestionably one of the most gifted draughtsmen, as proved by the breadth and diversity of his graphic work, denoting a marked taste for literature. We know that his library boasted the major books of his favourite poets, which he translated himself or sought to imitate in French verse. While the catalogue of the sale following his death on 11 April 1825 mentions hundreds of sketches or completed projects, we must add the countless studies—several as yet unpublished—for the illustration of famous texts, Greek, Latin, French, classical or modern. Girodet's name will always be associated with works by Virgil (pls. 35, 36), Racine's theatre, the *Odes* by Anacreon (pl. 37) and the *Loves of the Gods* by Ovid or the tale of *Daphnis and Chloe* by Longus (pl. 29).

According to the subjects he chose to treat, Girodet would alter his style, showing the same ease in handling the pen, graphite pencil or black pencil (pls. 35, 36, 38, 39). If he still turned to classical models for the organisation of his compositions, the artist balked at accepting unreservedly the constraints of a repertory he felt to be too hidebound and limited. When he chose to illustrate a contemporary literary subject—in this instance an episode from Chateaubriand's *Atala*—Girodet then appeared resolutely to shy away from the Neoclassical doctrine. However, on paper the difference is less marked: the preparatory studies in black pencil with white heightening were still drawn in a linear style (pl. 30). By contrast, a fair number of his pen drawings astonish—and delight—by their boundless freedom. Simplified to the extreme without losing its expressiveness, the more or less heavily inked line quivers with the impulses of an exacerbated sensibility.

Sometimes the pen scratches the paper and covers it with a tangle of lines that are overlaid without ever becoming muddled; at other times a few sinuous lines suffice to suggest an atmosphere, to compose a complex scene (pl. 31). Gifted with a fertile imagination, Girodet proves himself a poetic forerunner of the Romantic sensibility.

Among this small group of David's favourite pupils, Navez is a special case for several reasons. After arriving in Paris in May 1813 and entering David's studio shortly thereafter, a certificate delivered by his master the following year showed he was making swift progress, further confirmed by the favourable reception given the paintings he sent to the Brussels Salon in 1815. Having voluntarily chosen to follow David when he sought refuge in Brussels, Navez pursued his training under the latter's benevolent authority, and the bonds between the two men grew closer. David followed the youth's progress with interest. The sojourn Navez made in Rome from December 1817 to December 1821 did not alter their relationship since Navez continued to correspond with his master and ask his advice. And how David encouraged him! "Drawing, drawing, my friend, a thousand times drawing!" he wrote on 22 March 1818 on the subject of a *Holy Family* Navez sent him. "It is very difficult to put together cut figures without first doing a complete ensemble of the general movement of the figure, which is then squared so as to use only the part that enters in the painting" (WILDENSTEIN, 1973, no. 1814). After he returned to Belgium, Navez was perhaps even more intimately associated with David's concerns of his last years. Several of the paintings he executed at that time vouch for the fact (*Group of Musicians*, 1821, Williamstown, Mass., Sterling and Francine Clark Art Institute), and more notably a

monumental graphic composition whose emphatic treatment and concise composition somehow remind us of his master's uncanny late drawings. Apparently one of a kind, *The Deploration of Christ* (pl. 48) attracts our attention by the grieving intensity characterising the faces surrounding that of the Virgin. Still very close to David, Navez cannot have failed to see the drawings the latter executed during his absence, intensely marked by *morbidezza*, or suffering.

In the early nineteenth century, right within David's studio, the movement that would contribute to the explosion of David's ideas was born. Such an upheaval was certainly unavoidable, because the followers of the line, as we have seen, did not all defend it with the same energy. Even as they shared in the same adventure, the most gifted of David's pupils were the instigators of a renaissance, if not an authentic break, or at least a felicitous "deviance" that bore the seeds of the modern school. For a time frozen, the line was alive again, soaring, concentrating, having forsaken its intellectual foundation.

Chronology

1762 22 January: birth in Lille of Jean-Baptiste Wicar.
10 August: birth in Lyon of Philippe-Auguste Hennequin.

1763 24 November: birth in Paris of Jean-Germain Drouais.

1766 1 April: birth in Montpellier of François-Xavier Fabre.

1767 5 February: birth at Montargis of Anne-Louis Girodet.

1770 4 May: birth in Rome of François Gérard.

1771 1 March: birth in Paris of Antoine-Jean Gros.

1780 Drouais and Hennequin enrol in the studio of Jacques-Louis David; Wicar joins them in 1782.

1783 Drouais competes for the Prix de Rome on the theme of *Resurrection of the Son of the Widow of Naim* (Le Mans, Musée de Tessé). Because he took a section of his canvas to show to David, he is eliminated from the competition. Gérard enters the studio of the sculptor Pajou (1730–1809); Fabre joins David's atelier.

1784 9 January: Girodet tells his mother he works at David's studio every day.
Spring: Hennequin is in Rome, where in October arrive Wicar, David and Drouais, winner of the Prix de Rome with *The Woman of Canaan at the Feet of Christ* (Paris, Louvre).

1785 Gros enrols in David's studio. Wicar travels to Florence, where he is commissioned by the Grand Duke of Tuscany to draw the art works in the city galleries: he returns to France at the end of the year. Gérard enrols in the studio of Brenet (1748–1825) and, the following year, in the studio of David.

1787 Gros is admitted to the École des Beaux-Arts, where he wins a first-class medal and the Torso prize. Wicar accepts L.-J. Masquelier's invitation to help him execute the *Gallery of Florence*. Girodet enters the competition for the Prix de Rome (*Nebuchadnezzar Putting to Death the Children of Zedekiah*, Paris, École nationale des Beaux-Arts), but he is excluded for not observing the rules. The first prize is awarded to Fabre: loyal to the cause of the monarchy, he settles in Florence. *Marius at Minturnae* by Drouais (Paris, Louvre) is exhibited in Paris at his mother's after being widely acclaimed in Rome.
26 November: birth at Charleroi of François-Joseph Navez.

1788 15 February: death in Rome of Drouais. He is buried in the Church of Santa Maria in Via Lata.

1789 Girodet wins the first prize of the Prix de Rome competition (*Joseph Recognised by His Brothers*, Paris, École nationale des Beaux-Arts). The second prize goes to Gérard (*Joseph Recognised by His Brothers*, Angers, Musée des Beaux-Arts). Wicar publishes the first volume of the *Paintings, Statues, Bas-Reliefs and Cameos of the Galleries of Florence and of the Palazzo Pitti*.

1790 Girodet travels to Rome, where he paints *The Sleep of Endymion* (Paris, Louvre), which according to custom he sends to Paris. Gérard attempts the Prix de Rome once

again (*Daniel Defending the Chaste Susanna*, location unknown), but his father's death obliges him to depart for Italy. The following year he returns to Paris where, thanks to David, he is given lodgings and a studio in the Louvre. Because of his freemason convictions, Hennequin must leave Rome and returns to Lyon.

1793 Fearful of being denounced for his moderate opinions, Gros leaves Paris, intending to travel to Rome to further his training. Gérard is caught up in the 1793 recruitment and employed in the engineer corps. Appointed to the revolutionary court, he often avoids his obligations to the bench. Wicar in Rome takes part in the meetings of the Patriots' Society. Back in France in October to participate in the direction of the Conservatory, he exhibits at the Salon. The following year he is appointed curator at the Museum central des Arts in charge of antiquities and has lodgings in the Louvre.

1795 3 June: Wicar is interned in the former Collège du Plessis. Set free two weeks later, he leaves for Italy in the Fall. Gérard wins the competition organised in July by the Comité public d'Instruction with *The 10th of August 1792* (pl. 5); to earn a living he collaborates with Girodet, who has returned to France, in illustrating the editions of Virgil and Racine published by Didot. Hennequin leaves Lyon for Paris: he is confined in the Temple, sentenced to life imprisonment, then set free.

1796 Arriving in Genoa, Gros meets Josephine Bonaparte, who takes him with her to Milan. In December he starts *Bonaparte on the Bridge at Arcole, 17 November 1796* (Paris, Louvre). Wicar is first in Genoa, then in Florence and Rome with the Commission des Sciences et des Arts, engaged to select the works to be removed to Paris as compensation for war reparations owed to France.

1799 Girodet exhibits at the Salon the *Portrait of Mademoiselle Lange as Danaë* (Minneapolis, Institute of Arts) that causes a scandal, Hennequin, an allegory relating to *The 10th of August* (fragments in the museums of Angers, Le Mans and Rouen). Gros leaves Milan to seek refuge in Genoa before returning to France. Wicar oversees in Naples and then in Florence the requisitions ordered by the Directory.

1806 Settled in Rome since 1801, Wicar is appointed auditor and "director of foreigners" at the Academy of St Luke. Fabre exhibits at the Salon a *Repentant Magdalene* (Montpellier, Musée Fabre) and *The Sixth Eclogue by Virgil* (location unknown), Hennequin, *The Battle of the Pyramids* (Versailles, Musée national du Château), Girodet, *The Deluge* (Paris, Louvre) and Gros, *The Battle of Aboukir* (Versailles, Musée national du Château).

1808 Navez wins the first prize for life drawing at the Académie des Beaux-Arts of Brussels. Girodet exhibits at the Salon *The Entombment of Atala* (Paris, Louvre) and Gros, *Napoleon on the Battlefield at Eylau* (Paris, Louvre); both are made knights of the Legion of Honour.

1810 Still in Rome, Wicar is appointed correspondent of the Société des Sciences et des Arts of Lille. At the Salon, Fabre exhibits several portraits, Gros, *The Capture of Madrid* and *The Battle of the Pyramids* (Versailles, Musée

national du Château), Gérard, *The Battle of Austerlitz* (Versailles, Musée national du Château) and Girodet, the *Revolt at Cairo* (Versailles, Musée national du Château). He is awarded the prize of honour in the competition of the decennial grand prizes. Hennequin settles in Belgium.

1812 Girodet is commissioned to paint 36 full-length portraits of Napoleon in his coronation robes. Gérard is elected to the Institute. Gros exhibits at the Salon several paintings including *Charles V Received by Francis I at the Abbey of Saint-Denis* (Paris, Louvre) and Fabre, a *Holy Family Resting* (Montpellier, Musée Fabre). Hennequin settles in Liège. In the competition held by the Société de Gand, Navez wins the first prize in historical painting with *Virgil Reading Book VI of the Aeneid to Augustus* (Ghent, Museum voor Schone Kunsten). Thanks to the stipend awarded with the prize, he travels to Paris the following year to study in David's studio.

1815 Lucien Bonaparte commissions from Wicar *Portrait of Pope Pius VII* (Canino, cathedral). After Napoleon's departure for Elba, Gros is engaged to replace the portraits of the exiled emperor with those of Louis XVIII. Girodet is elected to the Institute. At the Salon of Brussels, Navez enjoys a great success that earns him the extension of his grant.

1816 Navez returns to Brussels. Gros is appointed a member of the Académie des Beaux-Arts. Wicar returns to Rome on 29 December after having exhibited in London *The Raising of the Son of the Widow of Naim* (Lille, Musée des Beaux-Arts).

1817 Wicar paints the *Portrait of Lucien Bonaparte with His Son Napoleon-Louis* (Rome, Museo Napoleone). Eugène de Beaumarchais commissions him for, among other things, a *Portrait of Pius VII* (Moscow, Pushkin Museum). Gérard exhibits *The Entry of Henry IV into Paris* (Versailles, Musée national du Château). He is appointed First Painter of Louis XVIII. In December, Navez arrives in Rome with a grant from the Société pour l'Encouragement des Beaux-Arts of Brussels. He will remain four years.

1819 Girodet is back at the Salon with *Pygmalion and Galatea* (Dampierre, château). Gros exhibits *The Embarkation of the Duchesse d'Angoulême at Pauillac* (Bordeaux, Musée des Beaux-Arts); he is promoted to officer of the Legion of Honour. Gérard is raised to baron.

1820 Navez completes the painting for his Brussels patrons, *Hagar and Ishmael* (Brussels, Musées Royaux des Beaux-Arts de Belgique). Pope Pius VII goes to Wicar's studio to see *The Raising of the Son of the Widow of Naim*.

1822 On his return to Belgium, Navez is widely acclaimed at Charleroi and then in Brussels, where he reunites with David. Appointed director of the Académie royale des Beaux-Arts of Brussels, he is also correspondent of the Institute of France and of Holland. At the Salon, Gros exhibits the painting commissioned by Louis-Philippe for his gallery of the Palais-Royal, *David in the Presence of Saul Calms His Black Moods with His Playing of the Harp* (auction, Christie's, New York, 19 May 1993, lot 35, repr.) and Gérard, *Corinne at Cape Misenum* (Lyon, Musée des Beaux-Arts).

1824 Gros completes the decoration of the dome of the Pantheon commissioned by Louis XVIII. He is raised to baron and takes advantage of this position to solicit David's return to France but without success. Gérard exhibits at the Salon *Daphnis and Chloe* (Paris, Louvre) and *Louis XIV Declaring His Grandson King of Spain* (Versailles, Musée national du Château, on deposit at the château of Chambord). Hennequin is named director of the Académie de Dessin of Tournai. Navez enjoys a brilliant success at the Brussels Salon with his *Massacre of the Innocents* (private coll.).
9 December: Girodet dies in Paris.

1827 At the Salon, Gros exhibits several portraits, Gérard, *Saint Theresa* (Paris, Maison Sainte-Thérèse) and Fabre, *Oedipus as a Child* (Caen, Musée des Beaux-Arts). Fabre is made knight of the Legion of Honour.

1834 27 February: Wicar dies in Rome, having bequeathed his collection to the city of Lille. He is buried at Saint-Louis-des-Français.
12 May: death of Hennequin at Leuze, near Tournai.

1835 Gérard paints *The Duc d'Orléans Accepting the Lieutenancy General of the Kingdom* (Versailles, Musée national du Château). Despite a poor reception by the critics, Gros nonetheless exhibits at the Salon, but decides to close his studio. 25 June, he drowns himself in the Seine near Meudon.
Navez exhibits at the Salon in Paris *The Sleep of Jesus* (Houyet, Church of the Assumption).

1837 11 January: death of Gérard in Paris. He leaves uncompleted a large painting, *Achilles, on Seeing the Arms His Mother Brings Him, Removes His Mourning Veil and Calls His Companions to Arms to Avenge Patroclus* (formerly Caen, Musée des Beaux-Arts; destroyed).
16 March: death of Fabre in Montpellier.

1869 12 October: death of Navez in Brussels.

PLATES

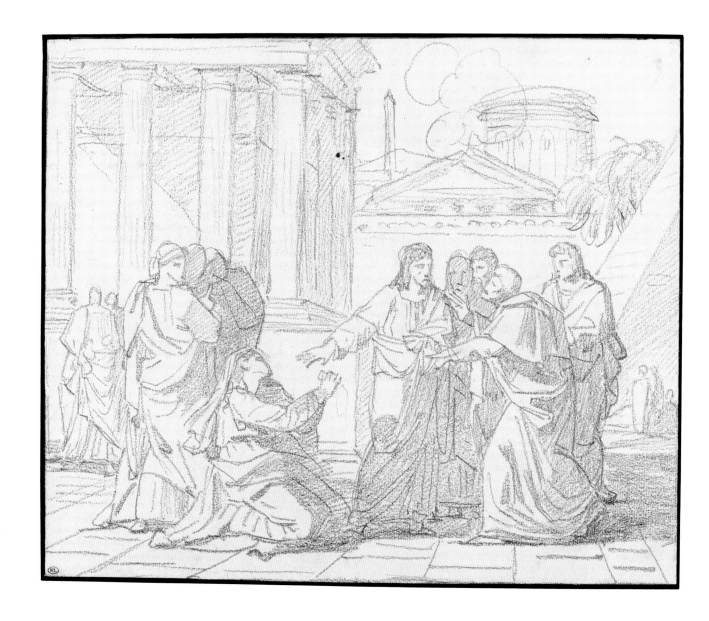

1. J.-G. Drouais, *The Woman of Canaan at the Feet of Christ*

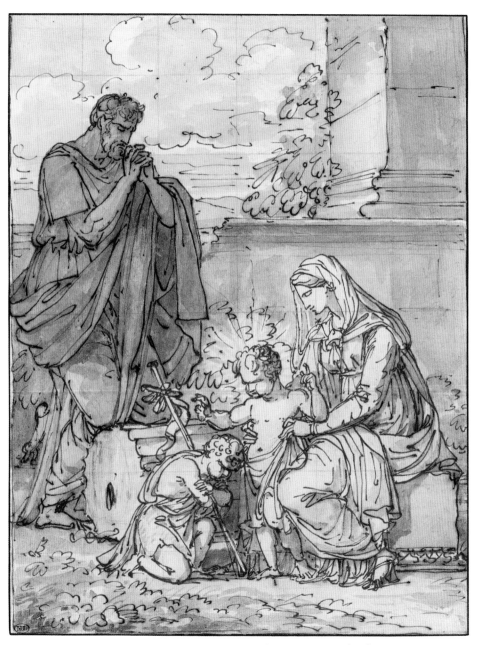

2. F.-X. FABRE, *Holy Family with the Infant Saint John the Baptist*

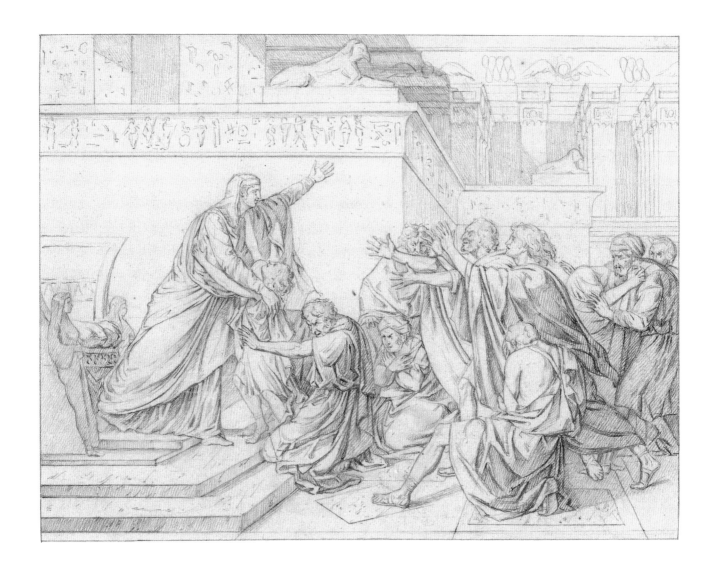

3. F. Gérard, *Joseph Revealing Himself to His Brothers*

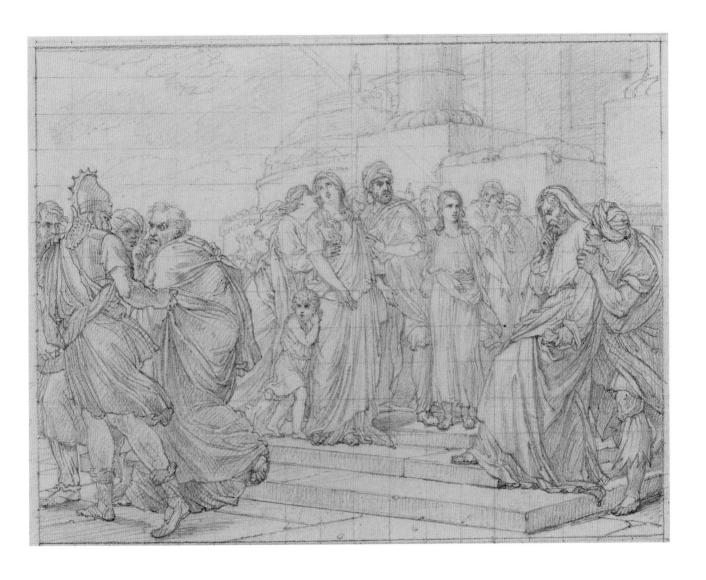

4. F. Gérard, *The Chaste Susanna Vindicated by the Prophet Daniel*

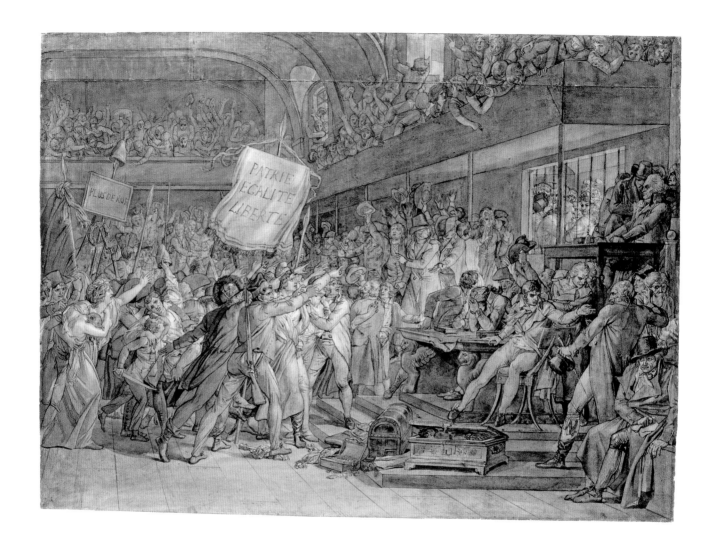

5. F. Gérard, *The 10th of August 1792*

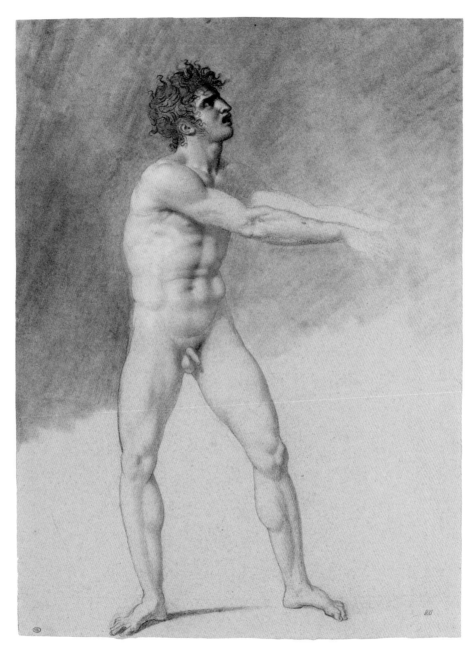

6. F. Gérard, *Nude Man, Standing, Arms Stretched Forward*

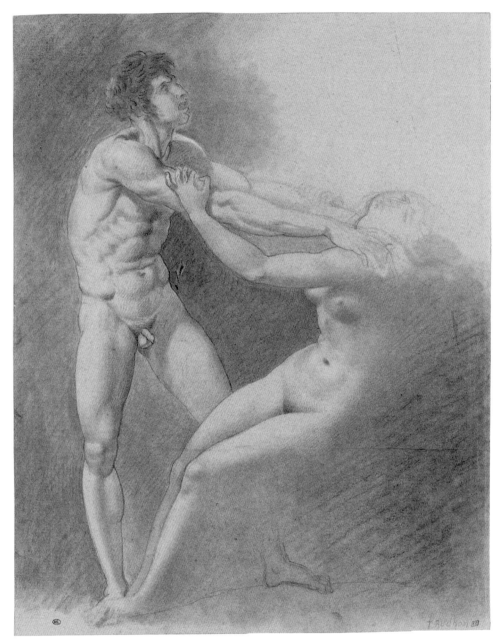

7. F. Gérard, *Nude Man Holding a Nude Woman by the Neck*

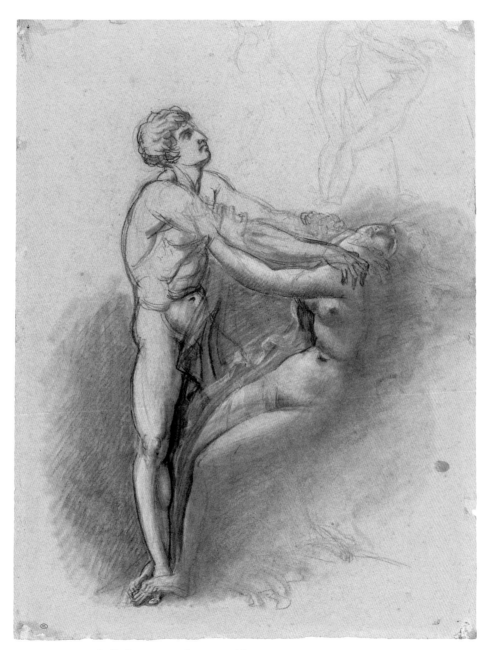

8. F. Gérard, *Nude Man Holding a Nude Woman by the Neck*

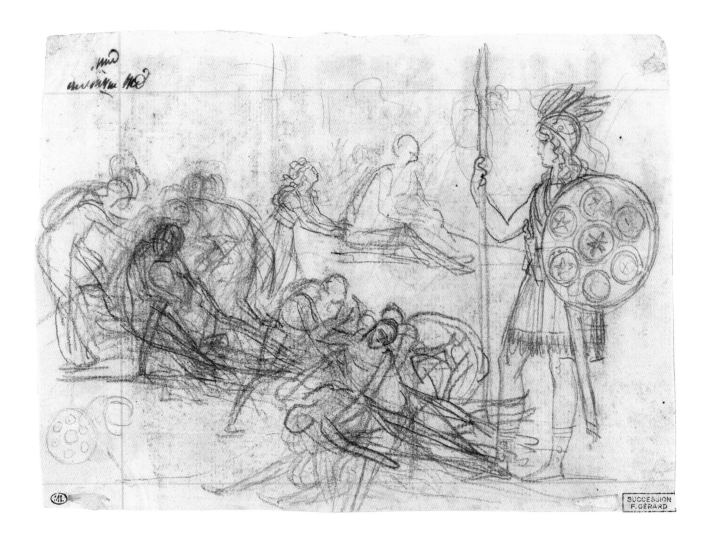

9. F. Gérard, *Warrior Gazing at Groups of Wounded*

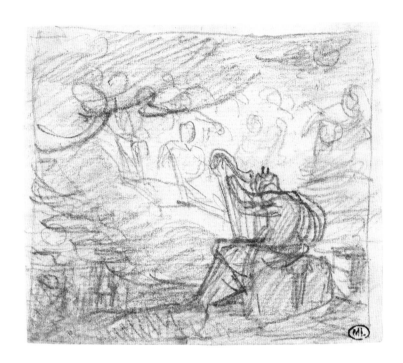

10. F. Gérard, *Ossian Singing*

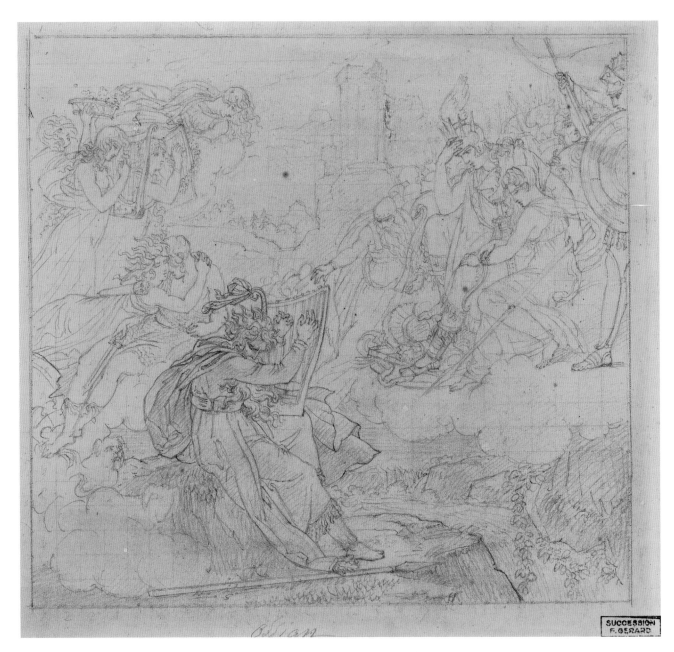

11. F. Gérard, *Ossian Evokes the Ghosts*

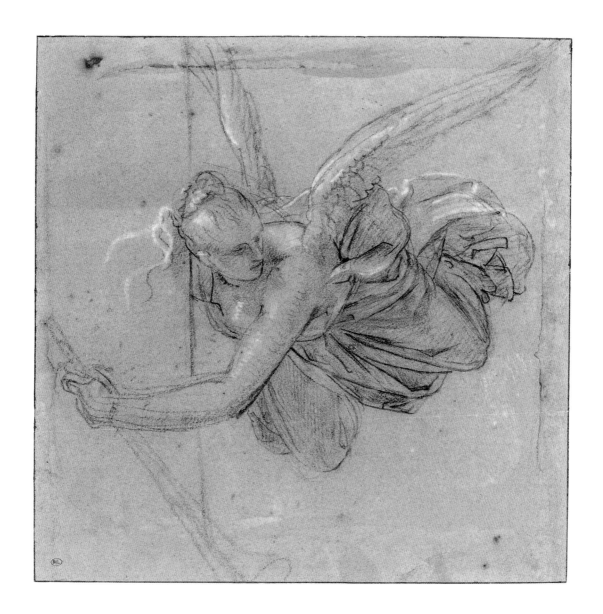

12. F. Gérard, *Figure of Fame*

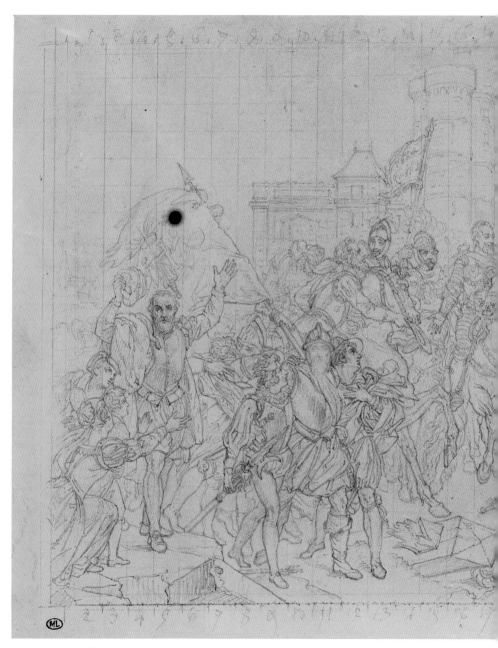

13. F. Gérard, *The Entry of Henry IV into Paris*

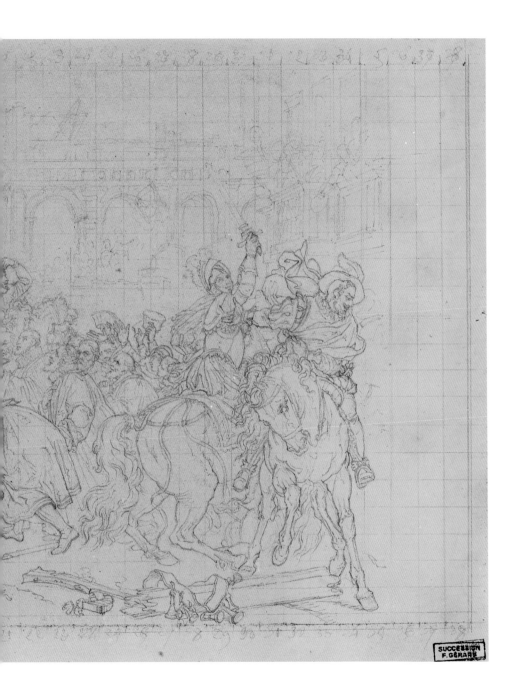

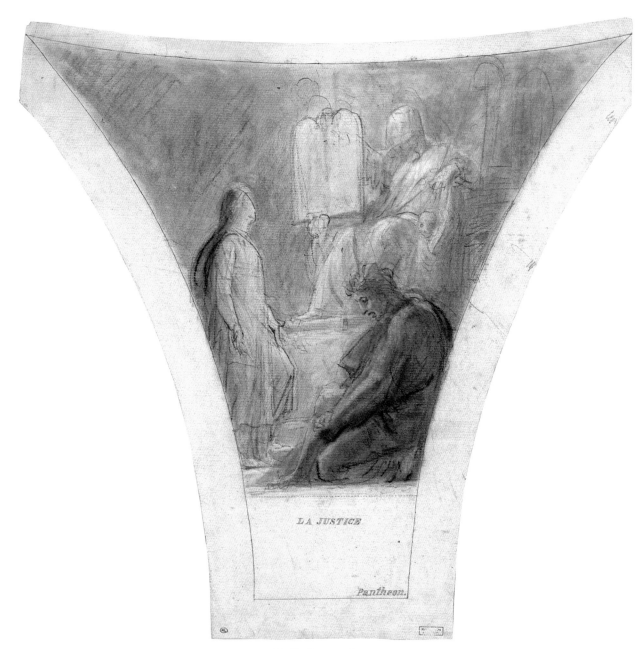

14. F. Gérard, *Justice*

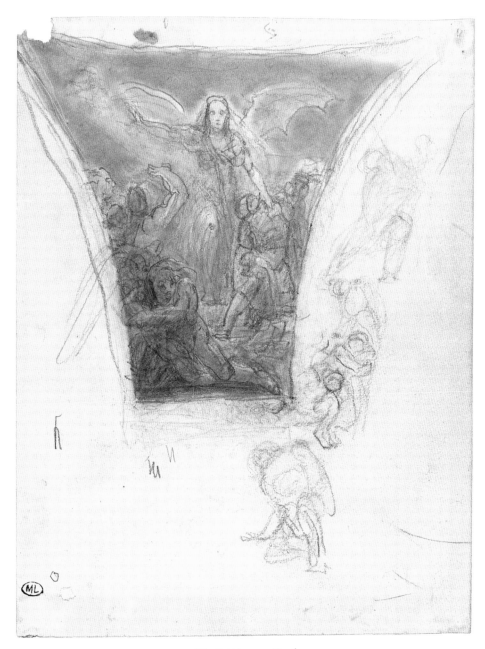

15. F. Gérard, *Death*

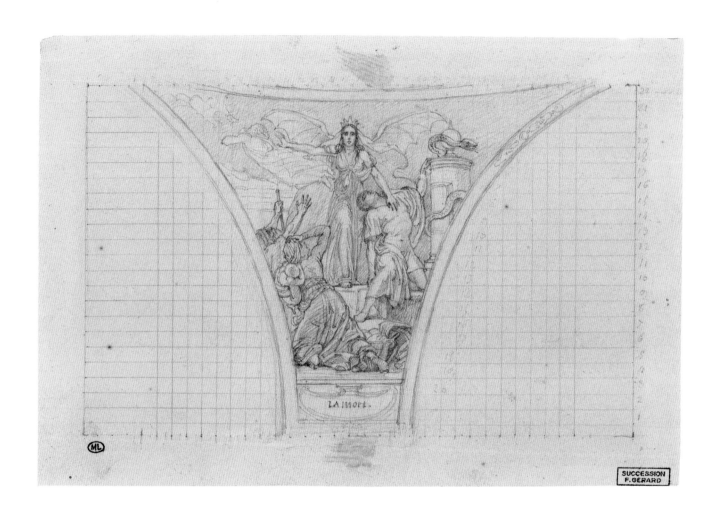

16. F. Gérard, *Death*

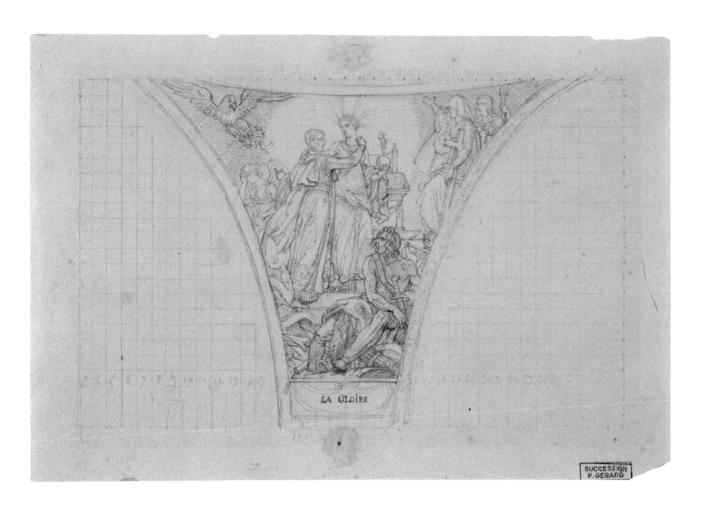

LA GLOIRE

17. F. Gérard, *Glory*

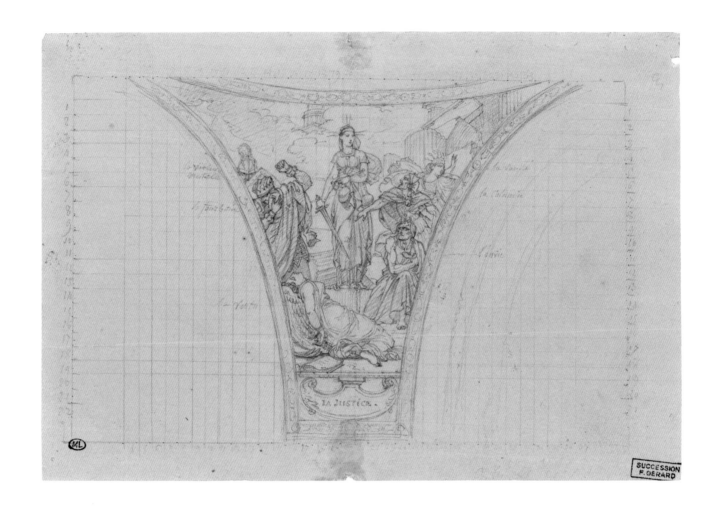

18. F. Gérard, *Justice*

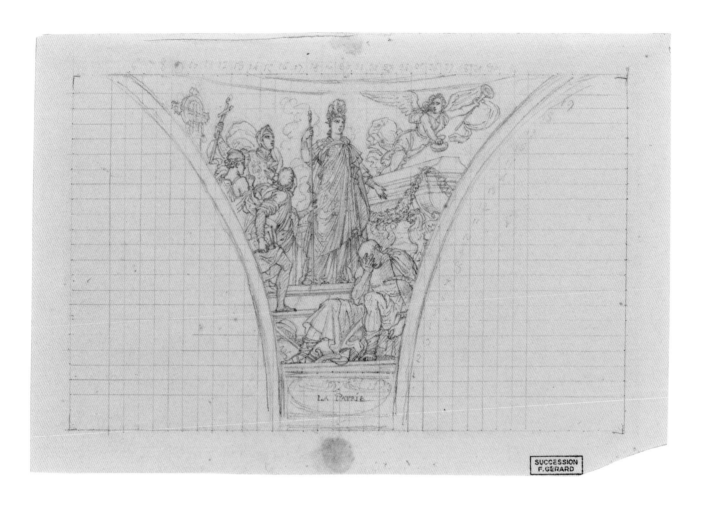

19. F. Gérard, *Native Land*

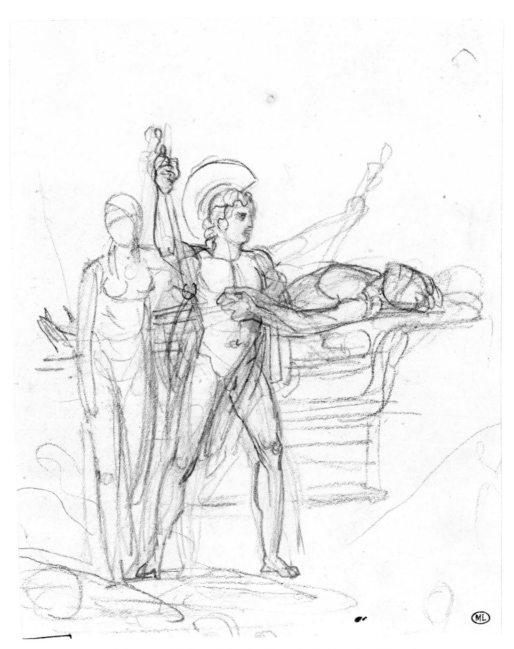

20. F. Gérard, *Achilles and Another Figure by the Remains of Patroclus*

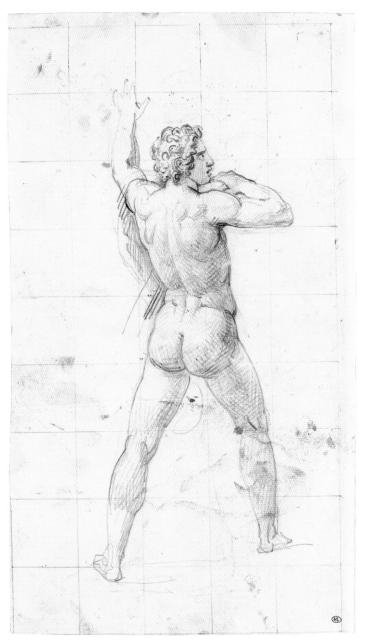

21. F. Gérard, *Nude Man, Seen from Behind, Moving to the Right, Left Arm Raised*

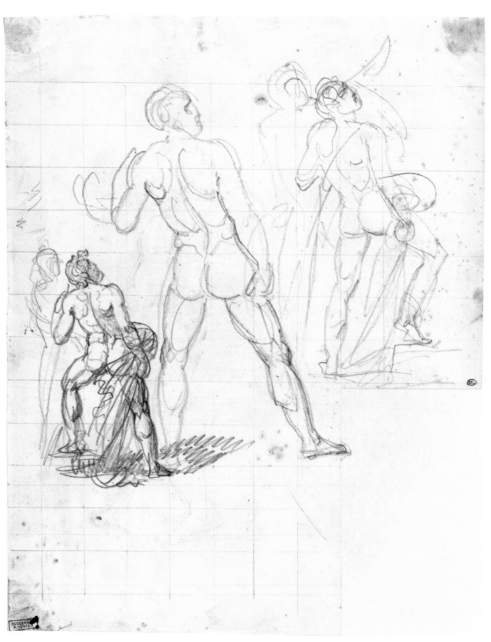

22. F. Gérard, *Three Studies of Nude Men, Seen from Behind, Head Facing Right*

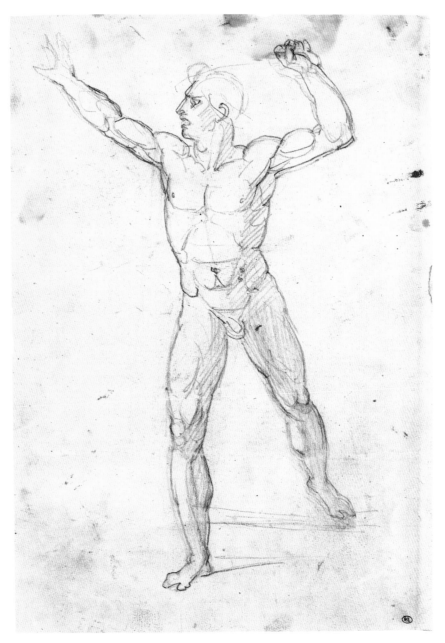

23. F. Gérard, *Study of a Nude Man in Frontal View, Arms and Legs Parted*

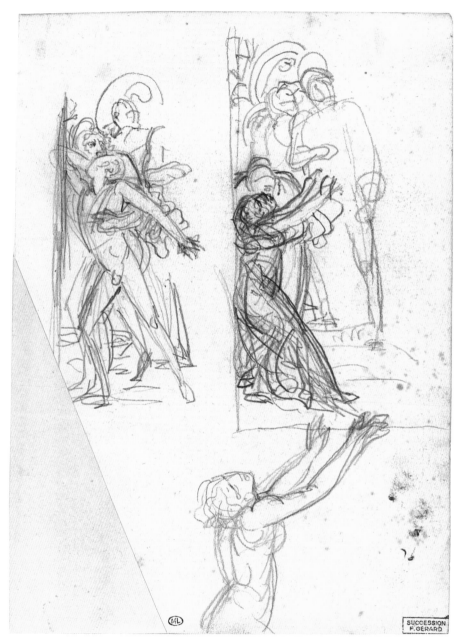

24. F. Gérard, *Two Groups of Nude Figures and Correction of One of Them*

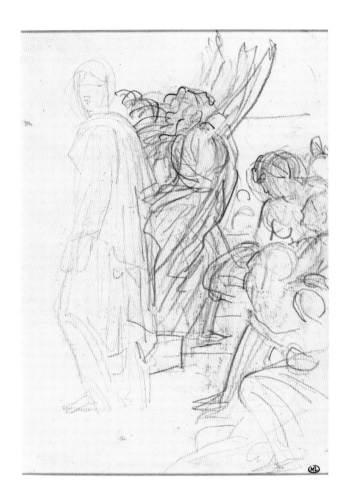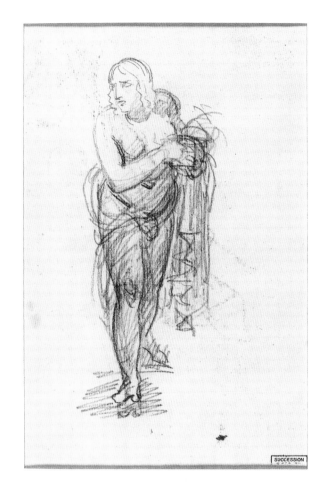

25. F. Gérard, *Group of Draped Figures, Standing or Kneeling*

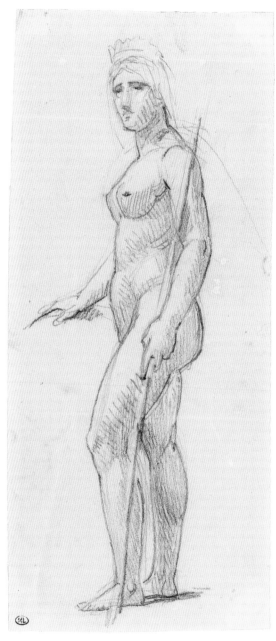

26. F. GÉRARD, *Study of a Nude Woman, Standing, Three-quarters Left, Wearing a Crown*

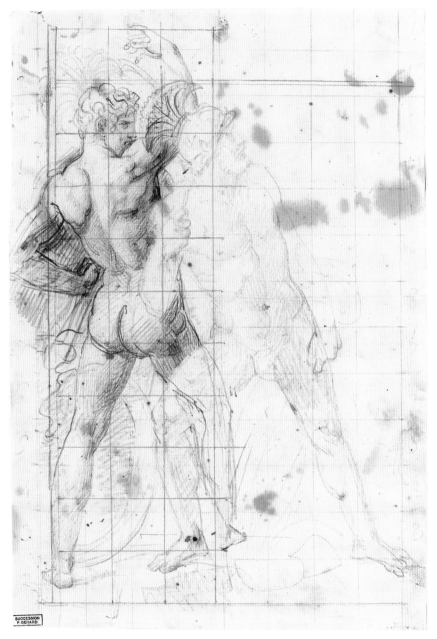

27. F. Gérard, *Study of Two Nude Men, Legs Parted, Heads Facing Right*

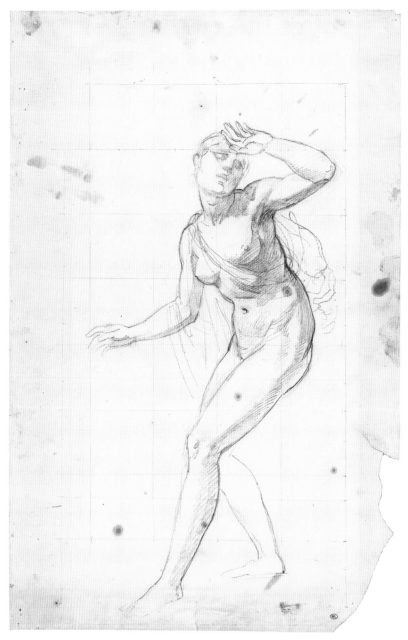

28. F. Gérard, *Study of a Nude Woman Standing, Moving to the Left, Her Hand Raised to Her Brow*

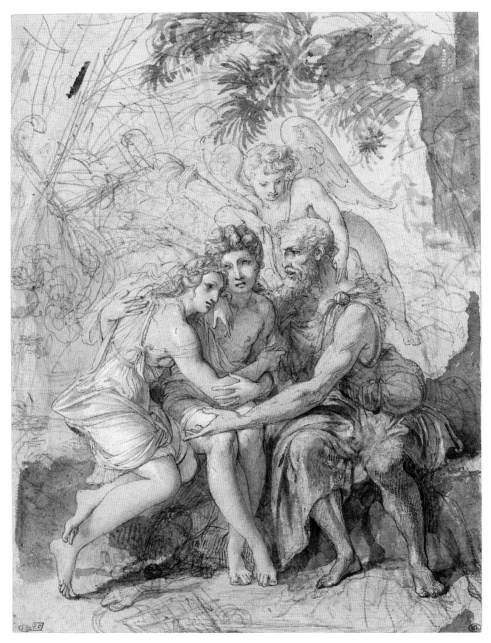

29. A.-L. GIRODET, *Daphnis and Chloe with the Shepherd Philetastas*

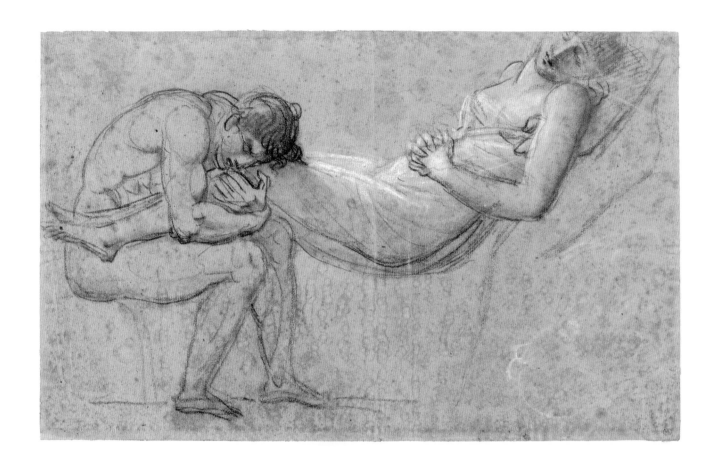

30. A.-L. Girodet, *Chactas Clasping the Legs of Atala*

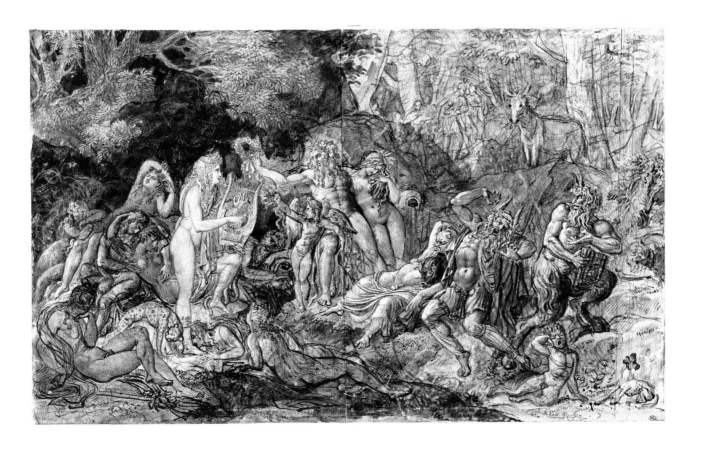

31. A.-L. Girodet, *The Judgement of Midas*

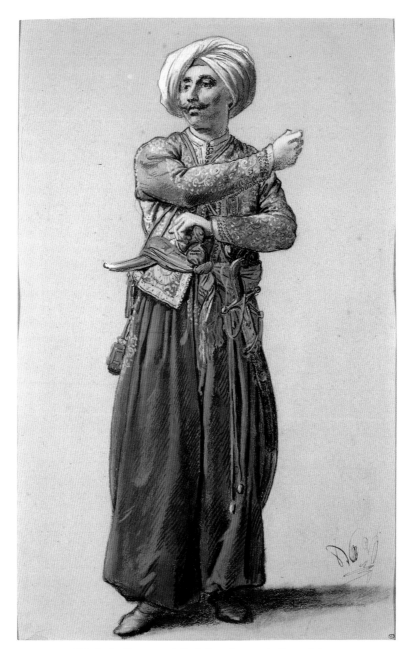

32. A.-L. Girodet, *A Turk Standing, with Crossed Arms*

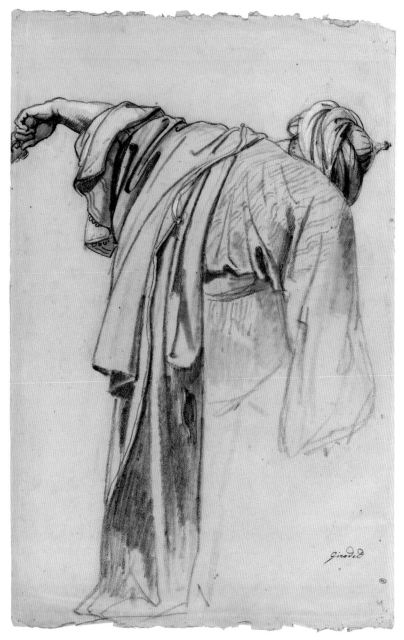

33. A.-L. Girodet, *Turk Seen from Behind, Head Bent, Wearing a Colourful Tunic with Red and Blue Stripes*

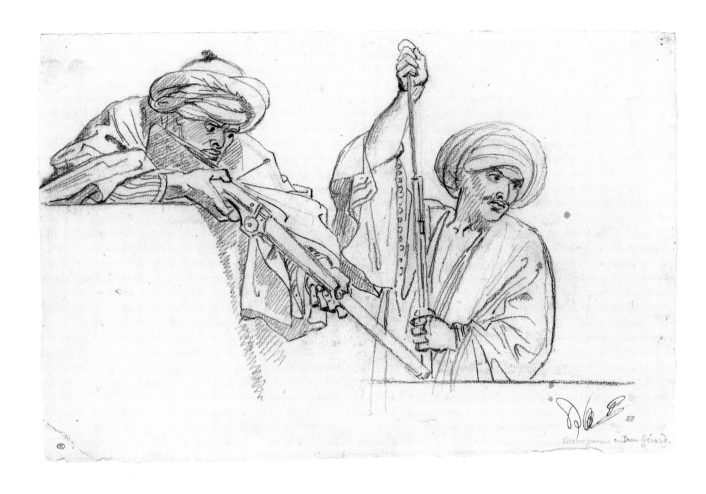

34. A.-L. Girodet, *Two Soldiers Donning Turbans and Oriental-Style Garb, behind a Wall*

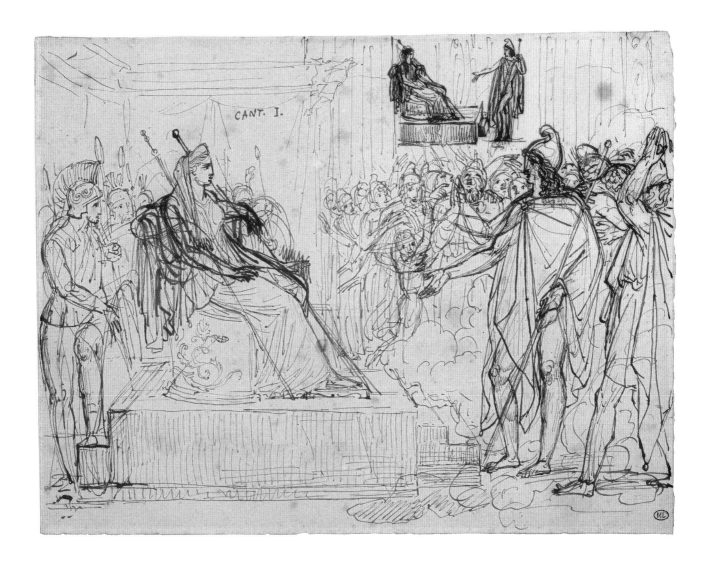

35. A.-L. Girodet, *Aeneas Appearing before Dido*

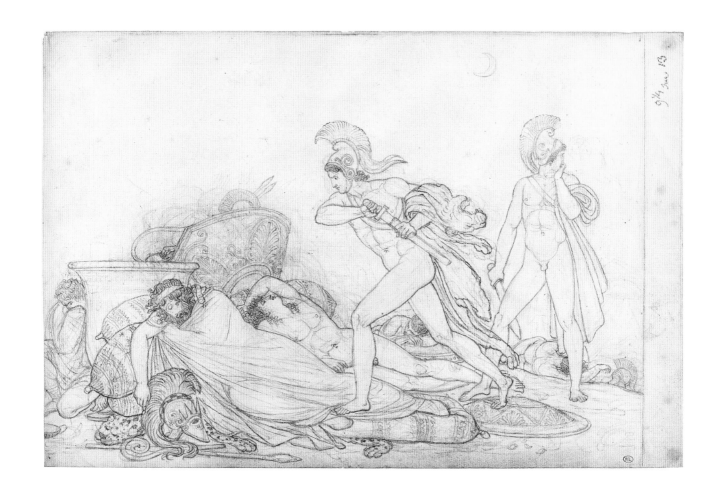

36. A.-L. Girodet, *Nisus and Euryale Crossing the Enemy Camp*

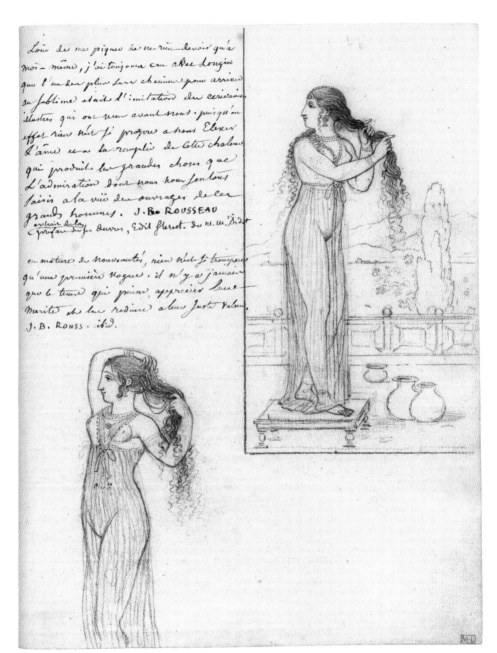

37. A.-L. Girodet, *Young Woman Combing her Hair*

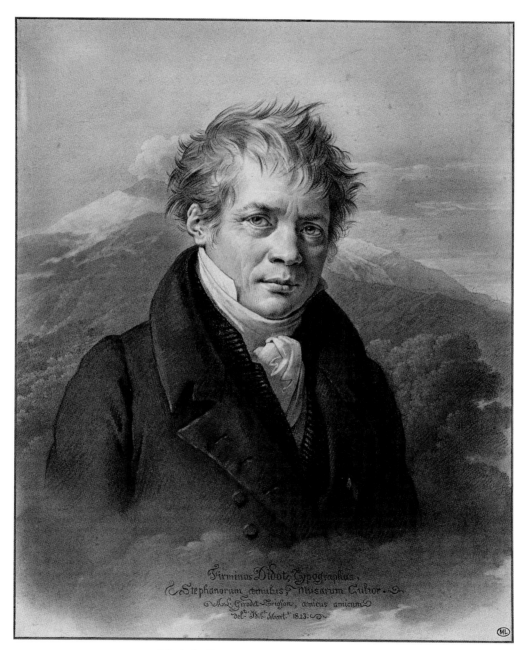

38. A.-L. Girodet, *Portrait of Firmin Didot*

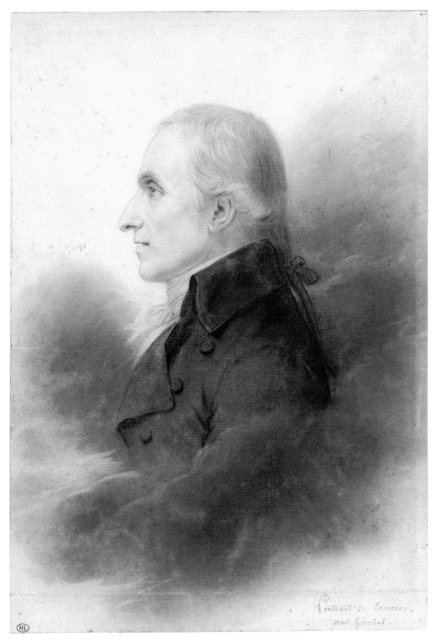

39. A.-L. Girodet, *Half-length Portrait of Canova, in Left Profile*

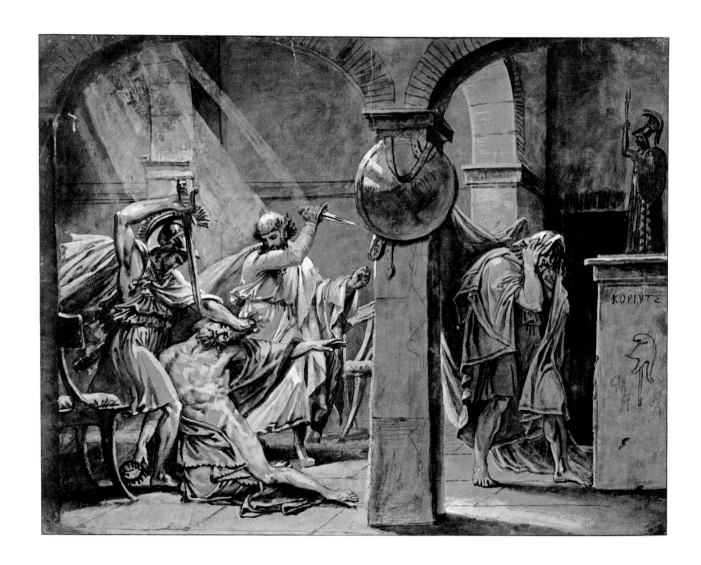

40. A.-J. Gros, *The Death of Timophanes*

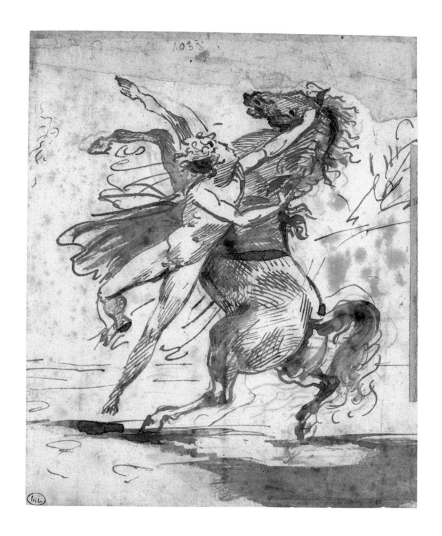

41. A.-J. Gros, *Alexander Breaking in Bucephalus*

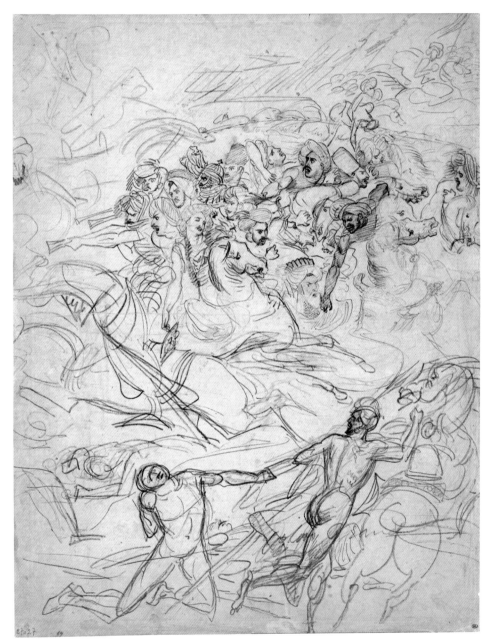

42. A.-J. Gros, *Turks Fleeing on Horseback*

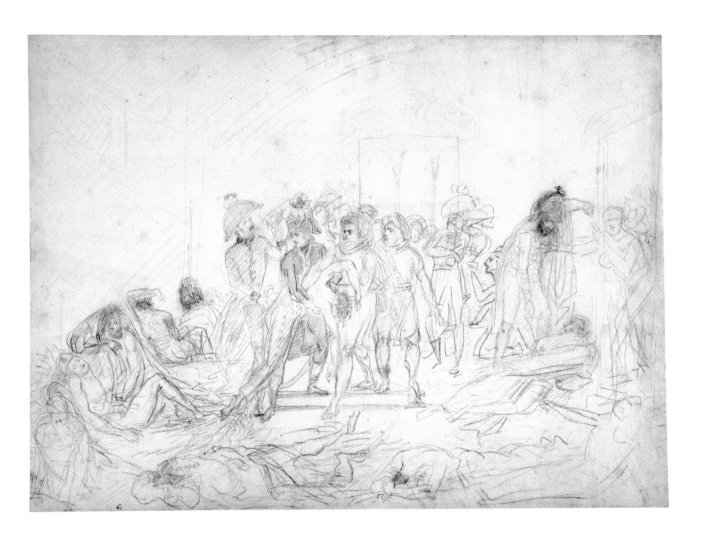

43. A.-J. Gros, *Napoleon in the Pesthouse at Jaffa*

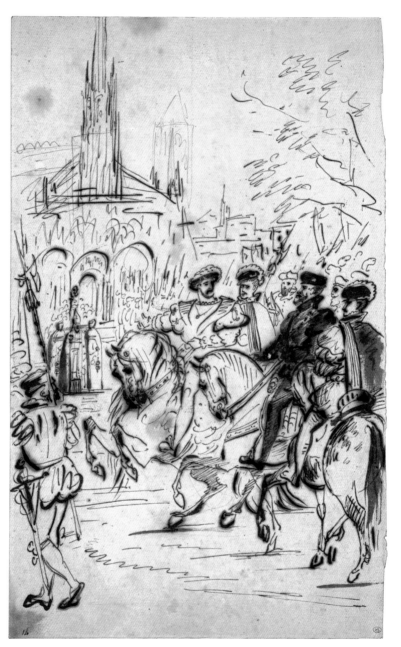

44. A.-J. GROS, *Charles V and Francis I in Front of the Abbey of Saint-Denis*

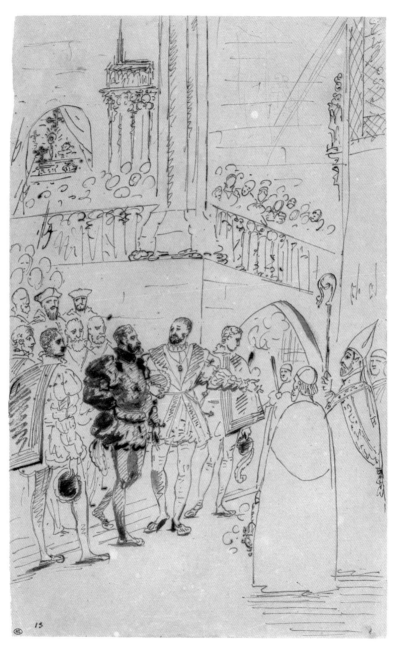

45. A.-J. Gros, *Francis I and Charles V at the Abbey of Saint-Denis*

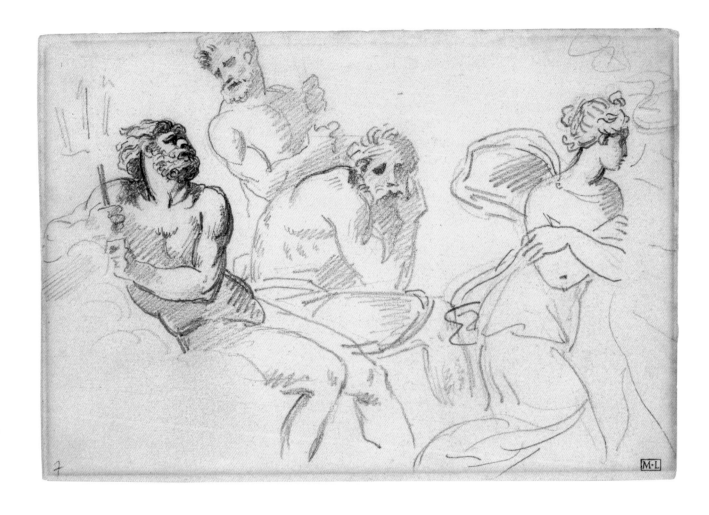

46. A.-J. Gros, *The Assembly of the Gods, after Polidoro da Caravaggio*

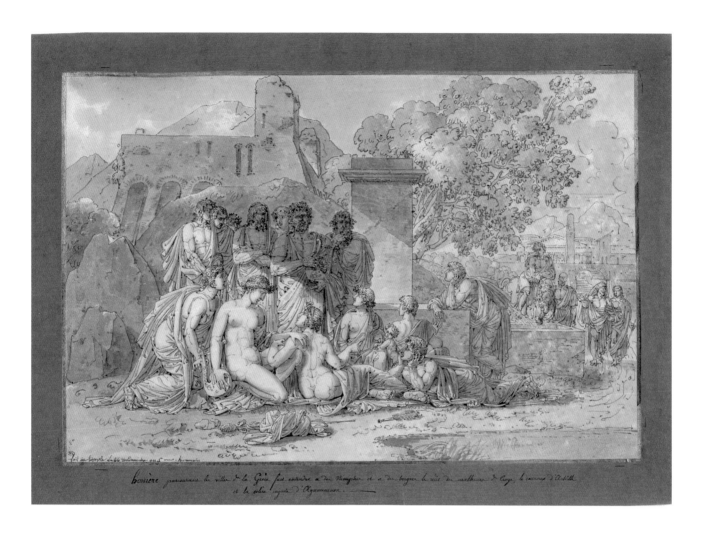

47. P.-A. Hennequin, *Homer Telling His Misfortunes in the Valleys of Greece*

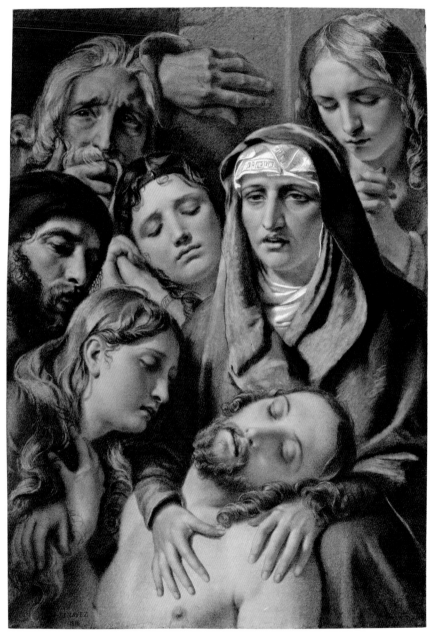

48. F.-J. Navez, *The Deploration of Christ*

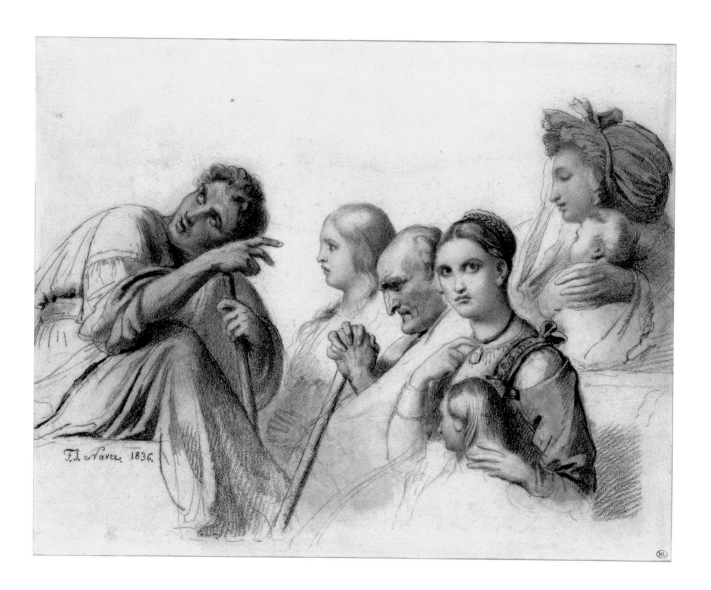

49. F.-J. NAVEZ, *Group of Figures*

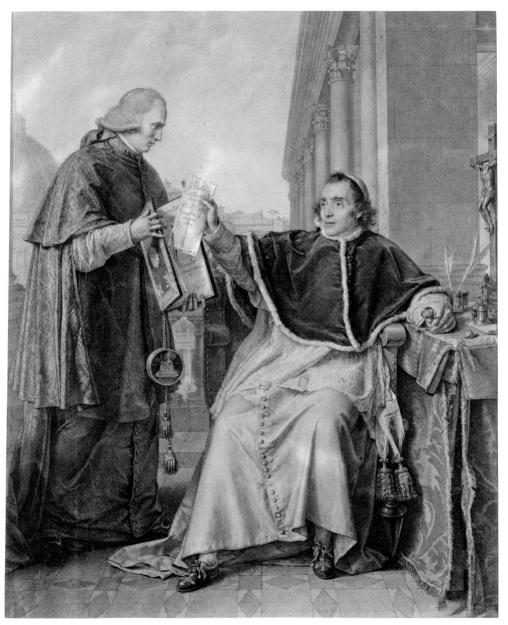

50. J.-B. J. Wɪᴄᴀʀ, *Pope Pius VII Handing over to Cardinal Consalvi the Ratification of the Concordat Signed in Rome between France and the Holy See, the Fifteenth of August 1801*

Catalogue

CATALOGUE

Entries by Arlette Sérullaz,
with the collabotation of Elodie Lerner for Gérard

JEAN-GERMAIN DROUAIS
Paris, 1763–Rome, 1788

1. *The Woman of Canaan at the Feet of Christ*
Red chalk. Mounted. 28.1 × 33.9 cm. Inv. 26 242

This is a study for the painting with which Drouais was awarded the Grand Prix de Rome in 1784 (Paris, Musée du Louvre). It so roused the admiration of his fellow students and rivals that they "crowned him with laurel, and despite his protests bore him in triumph to M. David's house, and then to his mother's" (CHAUSSARD, 1806, p. 339). In the final composition, the temple on the left is less imposing; the same is true for the buildings in the right background. Instead of blocking the horizon, they were shifted to the right. Note that the use of red chalk is exceptional in Drouais's drawn work.
Prov.: "Acquisition du Directeur" (D. V. Denon or the count of Forbin), cf. notebooks Morel d'Arleux, n.d., vol. VIII, that is, between 1802 and 1816. RAMADE, 1985, no. 6, repr.

FRANÇOIS-XAVIER FABRE
Montpellier, 1766–Montpellier, 1837

2. *Holy Family with the Infant Saint John the Baptist*
Pen and brown ink, brown wash, over graphite lines. Mounted. Squared in graphite pencil. Annotated lower left, in graphite pencil, on the mount: *6. Fabre.* 21.7 × 16.4 cm. Inv. 26 544

Seeking refuge in Florence in the first months of 1793, Fabre made himself known as a portraitist, while painting several antique or religious subjects in which David's influence is com-bined with that of Poussin. In this respect, the impressive *Holy Family* (2.24 × 1.60 m), signed and dated 1801 and which was shown in the Salon of 1812, is one of his most important productions (Montpellier, Musée Fabre). Commissioned by Serres, a native of Montpellier, and considered at the time Fabre's master-work, the painting, carefully prepared on paper, proves the artist had attained his full stylistic maturity.
At the sale of the Robert Dumesnil collection in 1845, the Louvre purchased two other drawings by Fabre catalogued under the same number 207: *Studies of Heads* (Inv. 26 546) and *Saint Jerome in Prayer* (Inv. 26 545).
Prov.: Purchased by the Louvre at the R. Dumesnil sale, Paris, 7–9 April 1845, no. 206. SÉRULLAZ, 1972, no. 79, repr.

BARON FRANÇOIS GÉRARD
Rome, 1770–Paris, 1837

3. *Joseph Revealing Himself to His Brothers*
Graphite pencil on cream-coloured paper. 22.4 × 25.6 cm.
Inv. RF 35 601

With the theme of Joseph recognised by his brothers after out of envy, they had sold him to traders on their way to Egypt (Gen. 45:1–4), Gérard entered for the first time in 1789 the competition for the Prix de Rome, winning second prize. The drawing is in a class by itself in the artist's work: its subject gave him licence to introduce exotic features (the *nemes* on Joseph's head, the hiero-glyphs and the Capitoline lions). In addition, rather than a preparatory study, it appears to be done after the painting shown in the competition (Angers, Musée des Beaux-Arts). Used to keeping an image of his works in engraved form, Gérard may have

intended to do so here. The highly finished aspect of this study, including the architectural details, a rather unusual trait in the artist's drawings, strongly intimates this. Rather than seeking a faithful reflection of the painting, Gérard gives the impression of trying to express its chief idea: the animation given to the scene by the general movement converging on Joseph and the variety of expressions, already strongly marked in the painting and here even more emphasised. In spite of these minor exaggerations, the young Gérard aspires to challenge the other, older laureates; indeed, his composition clearly reveals the progress he has made since joining David's studio. The master's strong influence at the time can be detected in the attitude of the figures recalling the postures of the heroes of *The Oath of the Horatii*. Furthermore, with its friezelike composition, the throne, the steps and even the gesture of the youngest brother, Gérard's work is comparable to that by Girodet, which had won first prize.

Prov.: Descendants of the artist, stamp lower right (not listed by Lugt); part of a group of 171 drawings by Gérard purchased by the Louvre in 1972.

4. *The Chaste Susanna Vindicated by the Prophet Daniel*
Graphite pencil, on beige paper. Numbered squaring in graphite pencil. Annotated in graphite pencil between the two framing lines: *la Chaste Suzanne justifiée / par le jeune David / tableau du concours pour le grand prix de Rome en 1790. Il n'a pas (?) été terminé.* 17.4 × 20.4 cm. Inv. RF 35 600

As the annotation in his hand indicates, Gérard again tried his luck at the Prix de Rome in 1790. The work represents Susanna vindicated by Daniel, who condemned the two elders who had sought to abuse her (Greek Supplements to the Book of Daniel 13). The

theme, recurrent in Gérard's work, of the application of the law in the face of an outburst of violence, whether individual or collective, appears notably in *The 10th of August 1792* (pl. 5). Like *Joseph Revealing Himself to His Brothers* (pl. 3), the present drawing, in its high degree of elaboration, might come after the painting (location unknown). Making use of one of his more outstanding skills, Gérard artfully arranges the countless folds of the draperies. The clear triangular composition culminates at the principal figures, including that of Daniel, who is surrounded by groups of animated figures with lively expressions, the group on the left forming a sort of circle. Quite accomplished, this composition could have won Gérard the award had his father's death not forced him to withdraw; in a letter dated 8 August 1790 the artist confides his sorrow to Trioson (private archives, Montargis, Musée Girodet). Failing to be represented in the competition, Gérard's painting was exhibited at the Salon of 1793, eliciting several brief but always enthusiastic comments.

Prov.: Descendants of the artist, stamp lower right (not listed by Lugt); part of a group of 171 drawings by Gérard purchased by the Louvre in 1972.

5. *The 10th of August 1792*
Pen and brown ink, brown wash, white gouache heightening. On three sheets of different formats[sizes?], joined. Signed lower left, in pen and brown ink, with the monogram. 67.0 × 91.4 cm. Inv. 26 713

On 10 August 1792 the national delegation voted the king's suspension, compelled by the populace that had invaded the Assembly meeting in the Manege. This theme won Gérard the first prize in the competition of the year II and the commission for

a painting called *National Monument*. In the highly finished composition of this drawing (note the care with which the anatomy of the figures is rendered), the artist surprisingly introduces a modification: next to the attested banners, he adds another one bearing the inscription "Plus de roi" (No more King). Gérard thus clarifies and radicalises the idea he wishes to express: the urgent issue is actually the destitution of this monarch who is turning his back—figuratively and literally—on the nation, as well as the neutralisation of his entourage, whose members are flaunting cunning, even impudent, expressions. This drawing, where the People's mission and the king's betrayal are clearly revealed, was executed between April 1794 and July 1795, that is, shortly before the events of Thermidor. A preliminary painted sketch (Vizille, Musée de la Révolution française), followed by this drawing, was done during the period in which the Jacobins took over; no significant change would be made to the design after their brutal fall from power. Gérard and his work were able to survive the ensuing political crisis thanks to the unifying aspect of the representation around a single goal: countering the royalists. In fact, this stance was still on the government agenda at a time when the partisans of Louis XVI were proving themselves particularly aggressive. Thus the youthful artist began to make his way with a work already rich with the qualities that would lead to his success: a harmonious configuration that efficiently delivered a strong message, the irruption of the People into History.

Prov.: Purchased by the Louvre at the Gérard estate sale, Paris, 27–29 April 1837, no. 23. GÉRARD, 1857, vol. VI; Moulin, 1983, pp. 197–202; MICHEL, 1989, no. 71, repr.

6. *Nude Man, Standing, Arms Stretched Forward*
Black pencil, stump, on blue paper. 44.9 × 33.1 cm.
Inv. RF 34 533

In 1798 Pierre Didot published a large folio edition of Virgil's *Works*, printed at the Louvre. Gérard and Girodet collaborated on this sumptuous book: Gérard with six drawings for *The Bucolics*, four drawings for *The Georgics* and six drawings for the *Aeneid*, and with Girodet designing the frontispiece of the book and six drawings for the *Aeneid* (SÉRULLAZ and LACAMBRE, 1974, pp. 62, 69–70, repr.). When it appeared, the book was received most favourably, especially, it would seem, because its presentation and typography were so well crafted. This drawing and the two following ones are intermediate studies for one of the illustra-

tions of Book IV of the *Georgics*, *Orpheus Holding the Dying Eurydice in His Arms*, engraved by Beisson after the model Gérard supplied and bearing in the lower margin the two verses by Virgil (vv. 499–500) that inspired the scene: "Dixit, et ex oculis subito, ceu fumus in auras / Commixtus tenuis, fugit diversa" (She spake, and suddenly, like smoke dissolving into empty air, passed and was sundered from his sight). There is a drawing directly linked to the etching in a private collection (oral communication, Élodie Lerner).

Prov.: E.-L. Calando, mark lower right (Lugt 837); Marguerite Calando; part of a group of 39 drawings purchased by the Louvre in 1970. SÉRULLAZ, 1984, pp. 217–21, fig. 6.

7. *Nude Man Holding a Nude Woman by the Neck*
Black pencil, stump, on blue paper. 42.5 × 35.6 cm.
Inv. RF 34 534

See pl. 6.

Prov.: E.-L. Calando, mark lower right (Lugt 837); Marguerite Calando; part of a group of 39 drawings purchased by the Louvre in 1970. SÉRULLAZ, 1984, pp. 217–21, fig. 1.

8. *Nude Man Holding a Nude Woman by the Neck*
Black pencil, stump, white chalk heightening, on blue-grey paper. 47.9 × 36.7 cm. Inv. RF 34 535

See pl. 6.

Prov.: E.-L. Calando, mark lower right (Lugt 837); Marguerite Calando; part of a group of 39 drawings purchased by the Louvre in 1970. SÉRULLAZ, 1984, pp. 217–21, fig. 2.

9. *Warrior Gazing at Groups of Wounded*
Black pencil and graphite pencil. Framing lines in pen and ochre. 15.7 × 21.7 cm. Inv. RF 35 616

This drawing and the two following ones are linked to two paintings on the theme of Ossian commissioned by Napoleon in 1800 from Girodet (Malmaison, Musée national) and from Gérard (destroyed) for Malmaison. In the latter, known in an etching by Normand, the man in arms on the right is comparable to the warrior in this drawing. The only detailed figure, the soldier contrasts

with the other figures whose poses are worked over by Gérard—hence the tangle of bodies. Unlike the coherent scenes we usually find in his drawn work, several studies are juxtaposed (here on the left is a separate sketch of the shield). This mingling of figures appears in another drawing as well (private collection). Thus it seems that although Gérard envisaged a final project, the compositional difficulties, evidenced by the Louvre study, explain why he finally gave it up. This first idea, of men pressing around a dying man, nonetheless accounts for the final composition: *Ossian* would first have been conceived as a scene of mourning, which probably explains its deeply melancholy mood.

Prov.: Descendants of the artist, stamp lower right (not listed by Lugt); part of a group of 171 drawings by Gérard purchased by the Louvre in 1972. Toussaint, 1974, no. 78, repr.

10. *Ossian Singing*
Black pencil, on blue-grey paper. 8.6×9.8 cm. Inv. RF 35 642

In this drawing, Ossian is seen already immersed in his music while behind him apparitions are intimated, such as the women flying on the left. Presenting forms which remain sketchy, this study nonetheless organises the structure of the composition. Gérard also immediately suggests the misty atmosphere of Nordic lands: the ethereal veil wrapping around the evanescent bodies gives the scene a sense of unreality. In so doing, the artist differs straight off from Girodet, whose conception of the subject is more complex. Furthermore, Gérard's *Ossian* reveals the timeless character of human emotions in the face of death, whereas Girodet's painting focuses on the actuality of the heroism of Napoleon's army. Gérard's absence from the Salon did not prevent his contemporaries from drawing a comparison between the two famous paintings. Thus, for Delécluze (1983, p. 253), Gérard did a "very pleasing finished sketch. But Girodet took the affair seriously and sought to outstrip his rival".

Prov.: Descendants of the artist, stamp lower right (not listed by Lugt); part of a group of 171 drawings by Gérard purchased by the Louvre in 1972. Toussaint, 1974, no. 77, repr.

11. *Ossian Evokes the Ghosts*
Graphite pencil, on buff paper. Squared in graphite pencil. Annotated lower centre, in graphite pencil: *Ossian*. 18.8×20.3 cm. Inv. RF 35 641

This drawing presents a squaring of the final composition that it clearly precedes, indicated by the conformity of the expressions and costumes and the unhesitating outline. The angular parts are almost eliminated, while the motif of the circle, also present in the two other preparatory drawings (pls. 9, 11), is prominent in the shield of the warrior on the right and in the handsome curve formed by Ossian bent over his harp before the ghosts of the past. An uncanny round looms in front of the castle of Selma: behind the bard seated on a rock, his son Oscar clasps Malvina; facing them is his father, Fingal, and at centre the aged poet Ullin. Gérard's composition presents all the features of the new sources of Ossianic inspiration which the publications of the Scottish poet Macpherson (1736–1796) had made famous.

Prov.: Descendants of the artist, stamp lower right (not listed by Lugt); part of a group of 171 drawings by Gérard purchased by the Louvre in 1972. Toussaint, 1974, no. 76, repr.

12. *Figure of Fame*
Black pencil, white heightening, on paper faded from blue. On the verso, correction of the same figure. Black pencil. 27.1×27.3 cm. Inv. 26 728

This is a first idea dating to 1807 for one of the allegories that would frame *The Battle of Austerlitz* on the ceiling of the Council of State at the Tuileries (the main composition is at Versailles, Musée national du Château, and the allegories are at the Louvre). They remained *in situ* when that painting glorifying the Emperor was replaced by another work by Gérard, this one glorifying the Bourbons when they ruled once again: *The Entry of Henry IV into Paris* (see pl. 13). The strange fate of these allegories matches the rather singular position of this drawing. Due to the goal pursued by the artist, who sought a decorative scheme appropriate for this kind of very large-size painting, meant to be seen from a distance, he used chiaroscuro effects to create sufficiently contrasted masses and a wide brushstroke to give the scene movement. In this drawing Gérard already insists on these two aspects: he renders luminosity by multiplying white highlights and faint hatching; to express the soaring appearance of the figure, rather than outlining the forms with his usual accuracy, he chooses to add softness to the contours. The verso offers a less advanced stage of this investigation.

Prov.: Part of a group of 20 drawings by Gérard offered to the Louvre by his nephew, Baron H.-A. Gérard, in 1851. Gérard, 1857, vol. VI; Guiffrey and Marcel, 1910, vol. V, no. 4133, repr.

13. *The Entry of Henry IV into Paris*
Graphite pencil, on brown paper. Numbered squaring in graphite pencil. 22.1 × 38.2 cm. Inv. RF 35 605

This highly finished and squared study precedes the painting ordered for the ceiling of the Council of State at the Tuileries (see pl. 12). At this advanced stage of his preparation, Gérard focuses on the figures, their expressions, their movements and their apparel. Putting an end to the authority of the members of the Holy League on 22 March 1594, the king strides toward the provost of merchants, custodian of the keys to the city of Paris. The pyramidal composition draws the eye toward the main point: the royal figure at the centre. During the exhibition of the painting at the Salon of 1817, the critics detected in this representation of a past event an allusion to a contemporary episode: like Henry IV, Louis XVIII is a legitimate monarch greeted with enthusiasm by a populace divided and exhausted after years of strife.
Prov.: Descendants of the artist, stamp lower right (not listed by Lugt); part of a group of 171 drawings by Gérard purchased by the Louvre in 1972.

14. *Justice*
Black pencil, stump, white heightening, on grey paper. Cut out in the shape of a pendentive. Annotated below in pen and black ink: LA JUSTICE / *Panthéon*. 44.4 × 47.0 cm (upper section) and 18.7 cm (lower section). Inv. RF 35 610

This drawing and the five following ones are preparatory studies for the pendentives of the Pantheon commissioned in 1821 (Archives nationales, F/21/578) and painted from 1831 to 1837. The overruling grey tonality and the ghostly appearance of the figures whose expressions are often vague give the scene a dramatic mood. Several sections are not yet clearly defined, including the left hand of the standing woman as well as the object, probably an open book, held by Justice. At this early stage, the artist is content to hastily place the various protagonists. In the final composition, Gérard used from this drawing only the figure in the lower section whose forceful expressivity immediately strikes the eye. By adopting a larger format than he was wont, Gérard also emphasises the monumentality of the figures, in order to harmonise his works with the existing decorative ensemble and especially to compete with the figures Gros painted on the dome.
Prov.: Descendants of the artist, stamp lower right (not listed by

Lugt); part of a group of 171 drawings by Gérard purchased by the Louvre in 1972. SÉRULLAZ, 1999–2000, p. 182, repr.

15. *Death*
Graphite pencil, stump, grey wash, gouache heightening. 16.2 × 32.3 cm. Inv. RF 35 611

Here Gérard prepares several key elements of the final composition, such as the rather dark tonality that he will lighten only slightly in the painting. He is already concentrating on the figures' expressions and the grandeur of their gestures. Death's gestures are particularly noteworthy; the figure stands out distinctly in a scene whose sketchy outlines cause the whole to be rather muddled. Struggling to arrange the figures clearly, Gérard adopts a procedure he already used in another drawing on this same theme (private collection). He makes sketches in the margin. Also a problem for the artist is making the figures conform to the shape of the pendentives. He makes several attempts to place the figures; the many corrections of the line indicate the difficulties yet to be overcome.
Prov.: Descendants of the artist, stamp lower right (not listed by Lugt); part of a group of 171 drawings by Gérard purchased by the Louvre in 1972.

16. *Death*
Graphite pencil, on beige paper. Numbered squaring in graphite pencil. 15.1 × 22.4 cm. Inv. RF 35 612

Highly elaborated, entirely squared and with firmly outlined forms, this drawing, as well as the next three, precedes the painted sketches (formerly Galerie Michel Roche), showing the artist's final conception for the Pantheon pendentives. The striking character of the scene can already be seen here: impassive, Death appears to be plunging onto the beholder; it spares Old Age and Childhood to fall upon a man in his prime whose soul rises toward its final resting place. Both beautiful and terrifying, the Reaper reminds us of several figures of Henry Fuseli. Our attention focuses on several other excellent parts that make up for a few occasional weaknesses, such as the rather awkwardly drawn serpent. The latter, perhaps borrowed from a motif reproduced in *Le pitture antiche d'Ercolano* (p. 207) of which Gérard owned a copy (Gérard estate sale, Paris, 22–27 April 1837,

no. 194), shows the importance the artist attached to antiquity as a source of inspiration.

Prov.: Descendants of the artist, stamp lower right (not listed by Lugt); part of a group of 171 drawings by Gérard purchased by the Louvre in 1972.

17. *Glory*
Graphite pencil, on beige paper. Numbered squaring in graphite pencil. 15.0 × 22.3 cm. Inv. RF 35 613

In this drawing rather stiff figures, artificially juxtaposed, look like antique statues (see pl. 16). The presence of allegories and the unreal luminosity emanating from the halo enveloping Glory appear alongside more realistic elements such as the musculature of the man in the foreground and above all the figure of Napoleon in ceremonial dress. The precision of the line, surprising in such a small drawing and manifest even in the shadows simulated by hatching, also reinforces the paradoxically verist aspect of this metaphoric representation for the Pantheon. The eagle carries off the mortal crown of the Emperor, wept over by Victory and on whom the Army, bearing the features of a Gallic warrior, casts a last glance; Religion, accompanied by Truth, shows Napoleon Heaven, like a promise of immortality.

Prov.: Descendants of the artist, stamp lower right (not listed by Lugt); part of a group of 171 drawings by Gérard purchased by the Louvre in 1972.

18. *Justice*
Graphite pencil, on beige paper. Numbered squaring in graphite pencil. Annotated along the edges, in graphite pencil, on the left: *la Violance / brutale / la Fourberie / la Vertu*; lower centre: *Justice*; on the right: *la Vanité/la Calomnie / l'Envie*.
15.1 × 22.0 cm. Inv. RF 35 614

In the midst of ruins, only the Pantheon, visible in the scattered clouds, remains open to Virtue. Coming to the rescue of the latter, overwhelmed in the foreground, majestic Justice crushes "Animal Violence", "Deceit", "Vanity", "Calumny" and "Envy". Gérard carefully noted the names of these figures along the frame and worked on their expressions in separate studies (Musée du Louvre, Inv. RF 35 662). The number of drawings on this theme shows the difficulties he encountered: it took ten years to realize

this composition, which at the end was very unlike the first ideas Gérard developed (see pl. 14).

Prov.: Descendants of the artist, stamp lower right (not listed by Lugt); part of a group of 171 drawings by Gérard purchased by the Louvre in 1972.

19. *Native Land*
Graphite pencil, on beige paper. Numbered squaring in graphite pencil. 14.9 × 21.9 cm. Inv. RF 35 615

Native Land points to the sarcophagus of a citizen, crowned by Fame and lamented by the People personified as a labourer. Under the auspices of Religion, symbolised by a cross, a soldier, a jurist and a craftsman, representing the three principal métiers of society, leap forward in turn to serve Native Land. As in *Glory* (pl. 17), this drawing for the Pantheon presents an astonishing combination of idealised aspects and realistic elements notably reinforced by the many studies made from life (Musée du Louvre, Inv. 26 729).

Prov.: Descendants of the artist, stamp lower right (not listed by Lugt); part of a group of 171 drawings by Gérard purchased by the Louvre in 1972.

20. *Achilles and Another Figure by the Remains of Patroclus*
Black pencil. 19.0 × 15.2 cm. Inv. RF 35 651

This study and the next eight are linked to an ambitious project on the theme of Achilles swearing to avenge the death of Patroclus, on which Gérard would work intermittently for twenty-seven years, in thirty-seven studies. Among these essays, five main stages can be distinguished: a study painted in 1810; a first version completed in 1819 (Tarbes, Musée Massey); a squared drawing (exposition-sale April 1992, New York, Jill Newhouse, p. 38, repr.); a last sketch (private collection), ca. 1830–1835; and, last, the final canvas (destroyed, formerly Musée de Caen). In 1840 Madame Gérard donated this last one to the École royale des Beaux-Arts, requesting the greatest care be given to "this work to which my husband applied himself above all others" (Archives nationales, AJ/52/448). Rarely seen, the painting nonetheless was soon famous: on 13 April 1813 Bertin wrote Fabre (1896, p. 12) that "Gérard has spent ages in front of a Homeric painting". In this study, which belongs to the beginning of this long, drawn-out cre-

ation, several ideas appear: the standing man with a very detailed face and clearly indicated movement contrasts with the rapidly sketched female figure; a first outline that arranges still very schematised forms can be seen under the final sketch. The overall organisation of the figures is more a juxtaposition than a composition since, as often with Gérard, the accessories tend to be neglected. Only the overall idea of the final composition is now settled: inspired by the *Iliad* (Canto 22), the artist represents Achilles giving voice to his desire for revenge in front of the remains of Patroclus who was killed by Hector.

Prov.: Descendants of the artist, stamp lower right (not listed by Lugt); part of a group of 171 drawings by Gérard purchased by the Louvre in 1972.

21. *Nude Man, Seen from Behind, Moving to the Right, Left Arm Raised*
Graphite pencil. Squared in graphite pencil. 36.0 × 20.6 cm. Inv. 26 733

This drawing, like the five following ones, belongs to the last stage of Gérard's thinking about his *Achilles and Patroclus* before the painted sketch (private collection) that preceded the final painting. Except for the hands and feet, neglected as the artist often does, the ensemble is quite elaborated. Gérard insists on the musculature, on the expression of the face—a combination of anger and determination—and on the figure's position, with a few pentimenti in the area of the left arm and leg. The representation of the two warriors in the left section of the canvas seems to have offered a particular challenge to Gérard, as the adjustments in the ten other studies reveal. Here the artist developed a first idea he doubtless intended to keep, to judge by the squaring: two men embracing, the right hand of the figure studied here resting on the shoulder of a figure indicated with only a very faint line. The presence of a spear in another drawing for this same group (pl. 22) also suggests that at the time the artist intended to recall the embrace of the male figures in *The Oath of the Horatii* by David. The motif of the martial union around the remains of Patroclus might have offered a parallel with that famous painting, but the comparison appears to have disturbed Gérard, who would abandon it (pl. 27), obviously seeking to distinguish himself from the master.

Prov.: Part of a group of 20 drawings by Gérard offered to the Louvre by his nephew, Baron H.-A. Gérard, in 1851. GUIFFREY and MARCEL, 1910, vol. V, no. 4154.

22. *Three Studies of Nude Men, Seen from Behind, Head Facing Right*
Graphite pencil, black pencil. Squared in black pencil. 38.4 × 30.4 cm. Inv. RF 35 654

Like the drawing above (pl. 21), this one concerns the male figures in the left section of the painting *Achilles and Patroclus*. In three sketches, from right to left becoming gradually more detailed, a man is represented seen from behind, in a position again reversed with respect to the one finally chosen, where he will appear in a frontal view. The outcome is rather heavy owing to the overlaying of the final contours of the bodies, firmly drawn, and to the great number of lines, linked to the studies of the figure's movement. It is the latter, rather than details, that interests the artist in this drawing, which is characterised by its fluidity, the fullness of the forms and the intense energy the ensemble irradiates.

Prov.: Descendants of the artist, stamp lower right (not listed by Lugt); part of a group of 171 drawings by Gérard purchased by the Louvre in 1972.

23. *Study of a Nude Man in Frontal View, Arms and Legs Parted*
Graphite pencil. 32.4 × 22.7 cm. Inv. 26 734

Energy and movement distinguish this study for the figure of Achilles, where nonetheless several uncertainties can be seen (note corrections on the face, the left foot and both arms). With the muscular body in tension combined with the intensity of the gaze, Gérard seems to have sought to express the great classical hero's determination.

Prov.: Part of a group of 20 drawings by Gérard offered to the Louvre by his nephew, Baron H.-A. Gérard, in 1851. GUIFFREY and MARCEL, 1910, vol. V, no. 4154.

24. *Two Groups of Nude Figures and Correction of One of Them*
Graphite pencil. 23.5 × 17.0 cm. Inv. RF 35 647

Insisting on the figures' expressivity, Gérard resorts to an extreme simplification of the forms and overlays the line until he achieves rather histrionic gestures. This sheet is one of a series of studies of figures for the most part quite different from what they will be in the final painting. Gérard concentrates on the protagonists of the scene: the two men in the foreground to the left, Achilles, a woman raising her

arms to the sky—in the centre of the composition—as well as Thetis. Prov.: Descendants of the artist, stamp lower right (not listed by Lugt); part of a group of 171 drawings by Gérard purchased by the Louvre in 1972.

25. *Group of Draped Figures, Standing or Kneeling*
Graphite pencil and black pencil. On the verso, standing figure, in frontal view, holding an object. Black pencil. 23.7 × 17.0 cm. Inv. RF 35 650

Here Gérard draws closer together several key figures of the composition, including the woman with her arms raised to the sky in the centre and Thetis. The attitude of the latter on the left, calm and static like a statue, differs from that of the other figures with their large gestures and full forms. Although sketchiness and incompletion distinguish the recto of this drawing, the verso presents massive forms drawn with a thick line. Pentimenti are visible since Gérard has not yet defined his ideas concerning this figure: it may be a trial for one of the protagonists in the centre background of the painted sketch.
Prov.: Descendants of the artist, stamp lower right (not listed by Lugt); part of a group of 171 drawings by Gérard purchased by the Louvre in 1972.

26. *Study of a Nude Woman, Standing, Three-quarters Left, Wearing a Crown*
Black pencil on yellow paper. 25.8 × 11.3 cm. Inv. RF 35 649

This is a study for Thetis who, in the final painting, will be represented in a green tunic, grasping the shield—merely suggested here—cast by Vulcan, with the helmet and the rest of the armour lying at her feet. From one drawing to the next Gérard accentuates the sculptural aspect of the silhouette, emphasising the importance and majesty of the goddess (see pl. 28).
Prov.: Descendants of the artist, stamp lower right (not listed by Lugt); part of a group of 171 drawings by Gérard purchased by the Louvre in 1972.

27. *Study of Two Nude Men, Legs Parted, Heads Facing Right*
Graphite pencil and red chalk. Squared in graphite. 36.9 × 25.5 cm. Inv. RF 35 648

These two figures—who in the painting appear in the foreground toward the left—which Gérard had first planned to represent embracing (see pl. 21), are in the end juxtaposed. This drawing, as well as the following one, also squared, precedes the final composition. Gérard corrects some key figures requiring further investigation: thus he is still unsure whether to equip the man seen from the back with a helmet or leave him bare-headed. Attention focuses on the determined expressions, the rendering of the shadows, the firm outline, the poses, the movement and the anatomy of the bodies.
Prov.: Descendants of the artist, stamp lower right (not listed by Lugt); part of a group of 171 drawings by Gérard purchased by the Louvre in 1972.

28. *Study of a Nude Woman Standing, Moving to the Left, Her Hand Raised to Her Brow*
Black pencil. Squared in graphite pencil. 45.7 × 29.8 cm. Inv. 26 731

Fear can be read on the face and is revealed by the gestures of this woman who appears again at the centre of the painting. The outlines of the body first seem to have been drawn rather hastily, and then to have been firmed up later to make the anatomy convincing. The corrections, still visible, prove Gérard's constant dissatisfaction in the course of his work, despite the energy spent to find the ideal composition. His first sketch so displeased him that he destroyed it in 1816 and left the last version of the scene uncompleted.
Prov.: Part of a group of 20 drawings by Gérard offered to the Louvre by his nephew, Baron H.-A. Gérard, in 1851. GUIFFREY and MARCEL, 1910, vol. V, no. 4152, repr.

ANNE-LOUIS GIRODET DE ROUCY-TRIOSON
Montargis, 1767–Paris, 1824

29. *Daphnis and Chloe with the Shepherd Philetas*
Pen and brown ink, brown wash, with white gouache heightening over graphite pencil underdrawing. 27.5 × 21.5 cm. Inv. RF 34 532

Daphnis and Chloe, a pastoral novel attributed to the Greek author Longus, tells the touching story of Daphnis and Chloe, two

children found by shepherds and raised together. Popularised in the late sixteenth century by Amyot's translation and reprinted throughout the eighteenth century, this book inspired a great many artists in the nineteenth century. In 1800 an edition illustrated after drawings by Prud'hon and Gérard was published by Pierre Didot. Girodet's drawing, which was perhaps meant to be engraved, shows the shepherd Philetas explaining to the two young people that they are in love. True to the text, Girodet placed above the group the hidden hero of the novel, Love, who is resting his hand on Philetas's shoulder.

Prov.: J.-A. Duval Le Camus, stamp lower left (Lugt 1441); E.-L. Calando, mark lower left (Lugt 837); Marguerite Calando; part of a group of 39 drawings purchased by the Louvre in 1970. MICHEL, 1989, pp. 132–34, no. 77, repr.

30. *Chactas Clasping the Legs of Atala*
Black pencil, white chalk heightening, on heavily foxed buff paper. 24.8 × 40.2 cm. Inv. RF 3973

After doing the portrait of Chateaubriand (Saint-Malo, museum) in 1807, Girodet presented at the Salon of 1808 a painting (Paris, Musée du Louvre) inspired by the author's famous novel, *Atala*, published in 1801 and the object of a score of reeditions during the next four years. The list of the paintings exhibited at the Salon after 1802 attests to the immediate interest Romantic artists felt for this imaginary tale of two young "savages" doomed to grief and to death, Chactas, member of the tribe of the Natchez, and Atala, born of the sinful love of an Indian woman converted to Christianity and a Spaniard. Girodet, who is certainly the most faithful interpreter of Chateaubriand's poetic prose, after some hesitation chose to illustrate the entombment of Atala, buried by Chactas and Father Aubry, united in their grief. The Louvre holds another drawing, more cursory, where Father Aubry is represented, nude, whereas Chactas's hair is knotted in Indian style (Inv. RF 3974).

Prov.: Bequest of Mlle Daria A. Pomme de Mirimonde to the Louvre in 1911. WAKEFIELD, 1978, pp. 13–22, fig. 18.

31. *The Judgement of Midas*
Black pencil, pen and brown ink, brown wash, white gouache heightening. On the verso, group of figures: *Bacchus Crowning Apollo*. Annotated in pen and brown ink: *A la fabrique de / Tabac rue Montmartre / vis-à-vis la rue du Jura* [?] / *Bourlot* [?].

40.1 × 50.2 cm, on two sheets joined in the middle.
Inv. RF 5346

In this astonishing composition in which the figures are set against a background of lush vegetation, Girodet follows Ovid (*Metamorphoses*, 11:279–80) with scholarly care, while interpreting the text in a highly personal manner. At the centre of the drawing, Tmolus, a mountain of Lydia—theatre of the contest that is to decide between the two rivals, Apollo and Pan—personified as an old man, embraces a young nymph, perhaps Daphne she hands a crown to Apollo who is playing the lyre, on the left. Young Eros, who rests on Tmolus's knees, also offers a crown to Apollo. Several nude figures are reclining on the left in both the foreground and the background. To the right, we see Silenus asleep with an amphora lying by his fat belly, Midas bemoaning, his head adorned with donkey's ears to punish him for his audacity (he dared take sides with Pan in the musical contest pitting the latter against Apollo), while Pan runs away with his flute. In spite of its complexity, the composition, filling the entire sheet, is perfectly legible because the different groups are so harmoniously arranged, defined by a tight, incisive graphic style. The sarcastic expression of Pan, the attitude of Midas writhing in despair, his mouth gaping, and that of the child satyr lying at his feet are a far cry from the canons of classical beauty so vaunted by Winckelmann's disciples. With its rich inventiveness and subversive spirit, the drawing, the ultimate use for which has, strangely enough, not been elucidated, is one of Girodet's masterpieces.

Prov.: Purchased by the Louvre at the sale of P. Becquerel, great-nephew of Girodet, Paris, 17 February 1922, no. 36. MICHEL, 1989, pp. 137–38, no. 80, repr. and p. 154.

32. *A Turk Standing, with Crossed Arms*
Black pencil, stump, pastel heightening, on beige paper.
Lower right, in pen and brown ink, four paraphs of which one is by A. N. Pérignon, disciple of Girodet, and annotated: *Girodet*. 47.0 × 30.2 cm. Inv. MI 1057

This drawing and the next two are linked to the large painting commissioned in 1809 by Napoleon I for the Galerie de Diane in the palace of the Tuileries, the *Revolt at Cairo*, and exhibited at the Salon of 1810 (Versailles, Musée national du Château). They probably belong to a group of drawings that for the most

part were heightened with pastel and included in the Girodet estate sale (Paris, 11 April 1825), presently dispersed among the museums in Paris (Louvre), Alençon, Avallon, Montargis, Cleveland and several French and foreign private collections. Girodet illustrates a gory episode in the Campaign of Egypt undertaken by Bonaparte to ruin British commerce by barring the trade route to the Indies. After the Battle of the Pyramids (21 July 1798), the French army entered Cairo, where Bonaparte established his headquarters with the intention of winning the Egyptians' good graces. The destruction of the French fleet by the English Admiral Nelson in the harbour of Aboukir (1 August) and the uprising that broke out in Cairo—put down after violent fighting—ruined his efforts. The Turk, seen from behind, wearing a colourful tunic splashed with red (pl. 33), appears in the painting at the far right, in the middle ground, holding a sabre in his right hand.

Prov.: Gift of the Widow Luillier to the Louvre in 1866 through M. Clément de Ris.

33. *Turk Seen from Behind, His Head Bent, Wearing a Colourful Tunic with Red and Blue Stripes*
Black pencil, stump, pastel heightening, on beige paper.
Annotated lower right, in pen and brown ink: *Girodet.*
47.0 × 30.2 cm. Inv. RF 4388

See pl. 32.
Prov.: Gift of G. Montfort to the Louvre in 1917.

34. *Two Soldiers Donning Turbans and Oriental-Style Garb, behind a Wall*
Black pencil. Lower right, in pen and brown ink, three paraphs of which one is by A. N. Pérignon, disciple of Girodet.
29.5 × 45.3 cm. Inv. RF 34 526

See pl. 32.
Prov.: E.-L. Calando, mark lower right (Lugt 837); Marguerite Calando; part of a group of 39 drawings purchased by the Louvre in 1970.

35. *Aeneas Appearing before Dido*
Pen and brown ink. 18.3 × 24.2 cm. Inv. RF 34 730

This drawing and the following one belong to the many studies associated with a project to which Girodet devoted himself in the 1810s, that of executing a new edition of Virgil's *Aeneid*, or even to do a more ambitious edition than the one of Pierre Didot, in which he had already participated in 1798. In a letter addressed to Coupin de la Couperie on 7 February 1811, Girodet confided to him: "I am more than ever determined to undertake this great enterprise [...]. I must make haste, my friend, because the years go by quickly, and even more so for me who am no longer young" (COUPIN, 1829, vol. II, pp. 309–10).

By the time he died, Girodet had already made more than 170 drawings, in either pen or pencil, which were sold to Antoine-Claude Pannetier. The latter undertook to lithograph seventy-two of them, assisted by a group of artists, pupils of Girodet, as he was. The book appeared in 1827 under the title *Énéide / Suite de compositions de Girodet / lithographiées d'après ses Dessins / Par M.M. Aubry Lecomte, Châtillon, Counis, Coupin, Dassy, Dejuinne, Delorme, Lancrenon, Monanteuil, Pannetier, ses élèves / Publiée par M. Pannetier / A Paris.* At Pannetier's death, the greatest part of the drawings entered the collection of M. De la Bordes and were purchased at his sale (Paris, Drouot, 15 April 1867) by the Firmin Didot family that kept them in its possession for almost a century. Swiftly sketched with a pen, *Aeneas Appearing before Dido*, illustrating a passage of Canto 1, was not lithographed, unlike *Nisus and Euryale Crossing the Enemy Camp*, which was carefully composed in graphite pencil and referred to a passage of Canto 9. This drawing was etched by Chatillon.

Prov.: Purchased by the Louvre at the Firmin Didot sale, Paris, Hôtel Drouot, 17 November 1971, no. 12.

36. *Nisus and Euryale Crossing the Enemy Camp*
Graphite pencil. Annotated crosswise, upper right, in graphite pencil: *9 1/4 sur 13.* 23.8 × 35.9 cm. Inv. RF 34 736

See pl. 35.
Prov.: Purchased by the Louvre at the Firmin Didot sale, Paris, Hôtel Drouot, 17 November 1971, no. 82.

37. *Young Woman Combing her Hair*
Black pencil. 23.0 × 18.0 cm. Annotated along the left border in pen and brown ink: *Loin de me piquer de ne rien devoir qu'a / moi-même, j'ai toujours cru avec Longin / que l'un des plus surs chemins*

pour arriver / au sublime etait l'imitation des écrivains / illustres qui ont vécu avant nous. puisqu'en / effet rien n'est si propre à nous élever / l'âme et a la remplir de cette chaleur / qui produit de grandes choses que / l'admiration dont nous nous sentons / saisis a la vüe des ouvrages de ces / grands hommes J. B. ROUSSEAU / extrait de la préface de ses œuvres. Edit. [?] de MM. Didot. (Far from priding myself I should be indebted to myself alone, I always agreed with Longinus / that one of the surest ways to achieve / sublimity was the imitation of the famous writers / who lived before us. Since indeed / nothing can uplift and fill our soul with that enthusiasm / which produces great things / as much as the admiration we feel in seeing / the works of these great men. J. B. Rousseau / extract from the preface of his works. Edit. By MM. Didot). Below: *en matiere de nouveautés, rien n'est si trompeur / qu'une première vogue. il n'y a jamais / que le tems qui puisse apprécier / leurs mérites et les réduire à leur juste valeur, J. B. ROUSSEAU, ibid.* (In matters of innovations / nothing is as deceptive / as a first vogue. There is nothing / but time that can measure their merits and reduce them to their true value, J. B. Rousseau). Inv. RF 54 204 to RF 54 231

A diligent reader of Anacreon's *Odes*, Girodet began to translate and illustrate them in 1808, planning to publish his book himself. As it happened, it was published a year after his death by his heir and through the good offices of Becquerel and Coupin (54 plates, Paris, Chaillou-Potrelle, Imprimerie de Firmin Didot), the etchings being executed by one of Girodet's pupils, Chatillon. Several of the drawings assembled in the volume whose binding is the work of Purgold, a Parisian bookbinder of German birth, are preparatory—sometimes in very free renditions—to the final drawings (such as Inv. RF 54 219, RF 54 221, RF 54 223). In the small sketches in the margin of the poems, Girodet's Neoclassical repertory is revealed in all the inventiveness of his imagination: winged cupids, frolicking, dancing, cupids making music, bacchic, martial or amatory vignettes, and so forth. On the verso of one sheet (Inv. RF 54 216), there is also a study for *Venus Rising from the Waters*, an important drawing held in the Louvre (Inv. RF 4144).

The two citations on the edges of the drawing come from the preface of the *Works* of Jean-Baptiste Rousseau (1670–1741), published in Brussels, and whose new edition, revised, corrected and augmented on the manuscripts of the authors, was on sale in Paris, at Didot's, in 1743.

The verso of the drawing features—among other things—five variants of the quatrain accompanying the scene of the apotheosis of Anacreon that Girodet had had engraved during his lifetime and the sketch of which is placed between folios 26 and 27 (Inv. RF 54 228), including the final formulation: "Ami de la sagesse et de la volupté, / Il sut, jusqu'au tombeau, chanter, aimer et boire. / En suivant les plaisirs, il rencontra la gloire, / Et conquit, en riant, l'immortalité" (Friend of wisdom and delights, / up to the grave he sang, loved and drank. / Pursuing pleasure, he met with glory, / and laughing, won immortality).

Prov.: Inserted between fols 29 and 30 of a group of 75 drawings and fragments of poems, purchased by the Louvre in 2004 with the participation of the CCF group, and having belonged to H. Beraldi and A. Piat.

38. *Portrait of Firmin Didot*
Black pencil, stump and white chalk heightening. Fully mounted. Annotated below in black pencil: *Firminus Didot, Typographus, / Stephanorum aemulus, Musarum Cultor. / A. L. Girodet-Trioson, amicus amicum / del. Idib⁵· Mart⁵ 1823.* (Firmin Didot, typographer, rival of the Estienne family, worshipper of the Muses, A. L. Girodet, from friend to friend, drew this portrait on the Ides of March 1823). 27.3 × 22.6 cm. Inv. 26 779

The younger son of François-Ambroise Didot (1730–1804), Firmin Didot (1764–1836) came from a long line of Parisian booksellers, printers and publishers who, beginning in the seventeenth century, distinguished themselves for their interest in technical innovation and their passion for everything relating to books. The first, François-Ambroise, succeeded in breaking free from the narrow confines of the traditions of the profession, inventing a new typographical system for measuring characters which was gradually accepted by all printers, the *typographical* or *Didot point*. Retiring from the business in 1789, he left his firm to his two sons. The elder, Pierre, was in charge of the management of the printing house, while Firmin devoted himself to the design of the characters. It was he who designed the characters of the large folios published at the Louvre by Pierre Didot and to which Girodet contributed illustrations of Virgil (see pls. 35 and 36), Horace and Racine.

The length of the dedication, the precision of its wording and the care given to its calligraphy prove the importance Girodet gave to this portrait and the nature of the bonds attaching him to his sitter, whose scholarly erudition and gifts for poetry were well known to him.

Prov.: Gift of the Didot family to the Louvre in 1848. Sérullaz, 1986, no. 20, repr.

39. *Half-length Portrait of Canova, in Left Profile*
Black pencil, stump. Annotated lower right in a different hand:
Portrait de Canova / par Girodet. 27.5 × 19.0 cm. Inv. MI 749

Beginning in the 1810s, Girodet executed various portraits whose
conception is comparable to this one, the model always being
drawn in black pencil, with or without white chalk highlights and
with a more or less frequent use of stump to define the back-
grounds. Here the half-length of the Italian sculptor Antonio
Canova (1757–1822) rises out of the clouds, exactly like the one
of Firmin Didot (pl. 38).
Prov.: Bequest of P. Ch. F. Delorme to the Louvre in 1860.
Levitine, 1965, p. 237, fig. 19.

Baron Antoine-Jean Gros
Paris, 1771–Meudon, 1835

40. *The Death of Timophanes*
Pen and brown ink, India ink and bistre wash with white gouache
heightening. Annotated in pen on the verso: *Timoléon / Dessin
de Jean-Antoine Gros / légué par Madame Augustine Dufresne /
veuve d'Antoine-Jean Gros / décédée le 5 janvier 1842 / au Musée
Royal du Louvre.* 45.0 × 58.0 cm. Inv. 27 024

The subject is drawn from Plutarch (*Timoleon*, 4). The Corinthian
general Timoleon ordered his brother Timophanes put to death
for having attempted on several occasions to usurp power.
According to Tripier Le Franc (1880), one of the first biographers
of Gros, the artist, early in 1798, when he was in Milan, had
begun various projects on paper, which would not be executed.
The episode of the death of Timophanes was one of them, for
which several pen sketches should be linked to the Louvre draw-
ing (Besançon, Musée des Beaux-Arts; formerly Delestre coll.).
Following the doctrine of Neoclassical aesthetics, Gros con-
structed the scene by arranging the figures on a plane, within a
massive and sober architectural background that divides the com-
position into two sections. The only decorative elements are the
shield and the sword hung at the top of the central pillar and the
statuette of Athena on the far right. In doing so, Gros took some
liberties with historical fact, since the tutelary gods of Corinth
were Apollo and Aphrodite. On the other hand, he borrowed
directly from Plutarch the attitude of Timoleon who veils his head
while his brother is being stabbed.

Prov.: Is this the drawing that figured in the Gros sale, Paris, 23
November 1835, no. 63: "La mort de Timoléon [*sic*], composition
de quatre figures et de la plus grande énergie"? Bequest of Madame
A. Dufresne to the Louvre in 1842. Michel, 1989, pp. 113–15,
155, no. 67, repr.

41. *Alexander Breaking in Bucephalus*
Pen and brown ink, brown wash. Strip joined to the upper
section. On the verso, correction of the same group. Pen and
brown ink. 14.0 × 11.8 cm. Inv. RF 34 522

We find in Plutarch (*Life of Alexander*, 9) the legendary story of
the very young son of King Philip of Macedonia breaking in a par-
ticularly stubborn and wild horse, Bucephalus (literally, "ox
head"), so named because of the white spot resembling an ox head
that it had on its forehead. Having understood that the animal was
frightened by his own shadow, Alexander put it facing the sun and
leapt on its back. By means of caresses, he was able to gallop with-
out being thrown, but up to its death the horse never allowed any
one else to mount it. Such a subject could but appeal to Gros, an
enthusiast of horses whose every movement he knew. Hanging
onto the mane of the rearing horse, whose tail is raised in a flour-
ish, the slender youth is swept up in a whirling movement that
seems to be inspired by a move from the ballet. There is another
drawing on this subject, in the same technique, but with a few
variants (private coll.; Delestre, n.d., fig. 21).
Prov.: E.-L. Calando, mark lower right (Lugt 837); Marguerite
Calando; part of a group of 39 drawings purchased by the Louvre
in 1970.

42. *Turks Fleeing on Horseback*
Graphite pencil and black pencil (?). Annotated above in graphite
pencil: *Cette partie plus élevée*; below: *plus grand*. On the verso:
unfinished sketch of two heads. Graphite pencil. Annotated
crosswise upper right: *Rue du Réservoir / NO. 17 / Chez M^{de} de /
tarley*. 60.4 × 46.7 cm. Inv. 27 027

Remarkable for the fiery interpretation of the dash of the horse-
men fleeing at full tilt in a compact melee, this quickly sketched
study is linked to the right-hand section of the sketch Gros
painted in 1801 (Nantes, Musée des Beaux-Arts), which won him
the contest held to recall a heroic episode of the Campaign of

Egypt, the Battle of Nazareth, during which General Junot, at the head of five hundred soldiers, routed an army of six thousand Turks (8 April 1799). In the Spring of 1802, Gros had established himself in the room of the Jeu de Paume (Tennis Court), at Versailles, to paint his picture when he received Denon's order to stop working on it, Bonaparte preferring that the artist use his brush for his own glorification. The subject commissioned under the new circumstances was Bonaparte's visit to the plague-stricken of Jaffa on 11 March 1799 (see pl. 43).
Prov.: Purchased by the Louvre from the painter A.-H. Debay in December 1851. TRIPIER LE FRANC, 1880, p. 198; MICHEL, 1989, pp. 129–30, no. 74, repr.

43. *Napoleon in the Pesthouse at Jaffa*
Black pencil. Annotated lower right, in black pencil: *Ce dessin de Gros est la véritable scène historique ou la première esquisse de son chef d'œuvre. Il représente le général Bonaparte relevant de sa propre main le cadavre d'un pestiféré pour ramener le moral abattu de ceux qui l'entourent. Tous semblent effrayés de son action, lui seul est calme, comme l'exprime sa figure. Cette scène était plus digne de la gloire du grand homme que la substitution d'une attitude plus noble en apparence, à l'élan d'un courage sublime. H.L.* (Hippolyte Larrey). (This drawing by Gros is the true historic scene or the first sketch of his masterpiece. It represents General Bonaparte picking up the corpse of a plague-stricken so as to revive the low spirits of those gathered around him. They all appear terrified by his deed, he alone is calm, as it is shown by his figure. This scene is more dignified of the glory of the great man than the substitution of an apparently nobler attitude, to the display of a sublime courage).
On the verso, various sketches including the group of a woman and a child in a landscape, inside framing lines, and another study for *Napoleon in the Pesthouse at Jaffa*. 49.0×67.8 cm. Inv. RF 2015

This drawing, which belonged to the chief surgeon of the army of Egypt, is a first idea for the large painting commissioned by Bonaparte and hailed by the critics at the time of its exhibition at the Salon of 1804 (Paris, Musée du Louvre).
According to the story told by Desgenettes, chief doctor of the army, Gros represented Bonaparte lifting up the body of a dying man, a gesture we find again in a small painted sketch (New Orleans, Isaac Delgado Museum) but which was not kept in the final composition, in which Bonaparte places his finger on the chest of a plague-stricken man. This modification, which appears

in a pen drawing as well (Paris, Prat coll.; ROSENBERG, 1995, no. 59, repr.) and in the sketch at the Musée Condé, Chantilly, may have been suggested to Gros by Denon, in order to connect Bonaparte's gesture with the royal tradition of the scrofulous (MOLLARET and BROSSOLLET, 1968, pp. 263–307).
Prov.: Baron J.-D. Larrey; Baron H. Larrey, his son; Gift of Mlle J. Dodu, goddaughter and general legatee of the former, to the Louvre in 1895. MICHEL, 1989, pp. 130–32, 155, no. 75, repr.

44. *Charles V and Francis I in Front of the Abbey of Saint-Denis*
Pen and brown ink, over graphite lines. Mounted. Annotated lower left, in pen and brown ink: *14.* 41.5×25.7 cm. Inv. RF 418

This drawing and the next one belong to the preparation for the painting exhibited at the Salon of 1812 (Paris, Musée du Louvre) and which was destined for the new sacristy of the Abbey of Saint-Denis. Wishing to glorify the monarchic conception and assert the bond uniting the imperial family and the ancient dynasties, Napoleon I decreed, on 20 February 1806, that Saint-Denis would shelter the monarchs' final resting place, in effect ordering the restoration of the church. According to the programme drafted by Denon, in 1811, ten paintings entrusted to ten artists, including Gros, Gérard, Girodet and Guérin, were to celebrate, in the sacristy raised by Cellerier, the great moments of the French monarchy since Dagobert. It fell to Gros to treat the subject "Charles V coming to visit the Church of Saint-Denis, where he is greeted by Francis I accompanied by his sons and the princes of his Court", that is, a stage in the journey Charles V performed between November 1539 and January 1540, having been invited by Francis I to cross his kingdom in order to crush the uprising in Ghent.
The first drawing shows the arrival of the kings in front of the abbey, while the second is directly related to the final composition where we see the kings inside Saint-Denis, with, to the left of Francis I, his second son, Charles d'Orléans, and to the right of Charles V, the Dauphin Henry.
Prov.: Purchased by the Louvre in 1878 from E. Oudinot. BOTTINEAU, [1973], 1974, pp. 255–81; SCAILLEREZ, 1992, no. 22 and fig. 37.

45. *Francis I and Charles V at the Abbey of Saint-Denis*
Pen and brown ink, several graphite pencil lines. Annotated lower left, in pen and brown ink: *13.* 41.9×25.5 cm. Inv. 27 023

See pl. 44.
Prov.: Purchased by the Louvre at the Gros sale, Paris, 23 November 1835, no. 99. Bottineau, [1973], 1974, pp. 255–81; Scaillerez, 1992, no. 22 and fig. 38.

46. *The Assembly of the Gods, after Polidoro da Caravaggio*
Ca. 1800/1805. Graphite pencil. Annotated lower left, in graphite pencil: 7. 12.1 × 17.5 cm. Inv. RF 52 105

Originally this small drawing was part of an album consisting of forty-eight drawings mounted on forty-seven sheets, which belonged to the Prouté firm before 1978 and was subsequently dismembered (Prouté cat., 1978, 2nd part, Drawings, no. 65). This album, doubtless one of the twenty-four described in the catalogue of the Gros sale (23 November 1835, no. 119), comprised several studies after the Old Masters (Veronese, Domenichino, Poussin, Carracci, etc.) along with sketches for several compositions by Gros, notably *Napoleon in the Pesthouse at Jaffa* (see pl. 43). The donation granted to the Louvre in 1995 by Louis-Antoine and Véronique Prat, subject to usufruct, includes a drawing from this album (Inv. RF 44 332; Rosenberg, 1995, no. 60, repr.). Here the artist drew the left-hand section of a painting by Polidoro da Caravaggio (1499/1500 ca.–1543?) conserved in the Louvre, which he also reproduced in full on another sheet of the album. The painting by Polidoro is an element of the decoration painted for the palace of Bern-Rota in Naples.
Prov.: Gift of M. and Madame Raymond Poussard to the Louvre in 2000. Sérullaz, 2002, p. 98, repr.

Philippe-Auguste Hennequin
Lyon, 1763–Leuze (near Tournai), 1833

47. *Homer Telling His Misfortunes in the Valleys of Greece*
Pen and brown ink, brown wash. Signed and dated lower left, in pen and brown ink: *fait au temple le 26 Vendémiaire 5ᵉ hennequin*. Annotated on the mount, below, in pen: *Homère parcourant les villes de la Grèce fait entendre à des nimphes* [sic] *et à des bergers le récit des malheurs de Troye, le couroux* [sic] *d'Achille / et la colère injuste d'Agamemnon* (Homer, travelling through the cities of Greece, tells the nymphs and shepherds the story of the misfortunes of Troy, the ire of Achilles and the unjust anger of Agamemnon). 28.4 × 43.5 cm. Inv. 27 194

Following the conspiracy, known as the *camp de Grenelle*, fomented in Paris by some followers of Gracchus Babeuf (9 September 1796), Hennequin was arrested on 10 September and taken to the Temple. Sentenced to life imprisonment on 9 October 1796, he was finally set free on 24 February 1797. Like his master David imprisoned in the Luxembourg after 9 Thermidor, during his incarceration Hennequin turned to the theme of Homer and composed this drawing, one of the most highly elaborated of his graphic production, where the figures appear to be inscribed on an antique pediment. The insistence with which the artist renders the musculatures, underscored by a fine, restless pen, as well as the expressions of the slightly caricatured faces characterise a good number of his drawings. The Louvre conserves another sheet by Hennequin, also given by the painter A. Couder: *The Heedless Demolishers Buried under Some Ruins* (Inv. 27 195; Benoît, 1994, no. D 232, repr.).
Prov.: Gift of the painter A. Couder to the Louvre in 1836. Benoît, 1994, no. D. 71, repr.

François-Joseph Navez
Charleroi, 1787–Brussels, 1869

48. *The Deploration of Christ*
Black pencil, stump, white chalk heightening, on buff paper. 95.5 × 66.5 cm. Inv. RF 52 963

For a long time unlocated, this spectacular drawing, by its dimensions as well as by the choice of its composition, is one of the most significant works executed in the years 1816–17 by Navez, who had returned to Brussels where his master David was living after being compelled into exile. Until his departure for Italy, Navez had worked by David's side and created several of his masterworks: portraits (*De Hemptinne Family*, 1817, Brussels, Musées royaux des Beaux-Arts de Belgique) and religious scenes (*Saint Veronica of Milan*, private collection). He was furthermore supported in his work by Auguste-Donat De Hemptinne (1781–1854), who at a very early date noticed the young artist and regularly commissioned works from him. *The Deploration of Christ*, if it obviously recalls *Saint Veronica*, commissioned by De Hemptinne, should be compared with David's strange Brussels drawings. Navez borrowed here the unusual formula adopted by his master, assembling on the same sheet figures in half-length, with tormented expressions, pushing the effect to extremes.

Unquestionably, this is the artist's masterpiece.
Prov.: A.-D. De Hemptinne; kept by his descendants until 2003; purchased at that date by the Louvre. COEKELBERGHS, JACOBS and LOZE, 1999, p. 74, fig. 111.

49. *Group of Figures*
Black pencil, stump. Signed and dated, lower left, in black pencil: *F. J. Navez. 1836.* 26.5×32.8 cm. Inv. RF 43 413

In its subject this drawing can be compared with the painting conserved in the Louvre, signed and dated 1830, *Italian Family*, also known as *Peasants Resting in the Roman Countryside* (Inv. RF 1993-5). Having said this, the relationship of the drawing with the "Italian scenes" that Navez continued to paint after his sojourn in Italy (see on the subject COECKELBERGS, JACOBS and LOZE, 1999, pp. 125–35) is entirely relative, for we can but note that there is no real link between the figures arranged on the sheet. In this regard, the spoilsport is the man seated on the left (a recollection or derivation of studies made either after the antique or after Michelangelo or Raphael). The unusual aspect of the scene inevitably reminds us of David's late drawings, which left such a lasting mark on Navez. Less striking than *The Deploration* (pl. 48), this drawing nonetheless constitutes a revealing testimony of the originality of Navez, who endeavours here to synthesise David's influence and the lessons he learned in Italy.
Prov.: Galerie Leegenhoek, Paris; purchased by the Louvre in 1994.

JEAN-BAPTISTE JOSEPH WICAR
Lille, 1762–Rome, 1834

50. *Pope Pius VII Handing over to Cardinal Consalvi the Ratification of the Concordat Signed in Rome between France and the Holy See, the Fifteenth of August 1801*
Black chalk and charcoal, white chalk heightening, on cream-coloured paper. Annotated in black chalk on the Concordat held by the cardinal: *Concordat / Signatu / Parisii / die 15 Julii / anni 1801*, and on the bull held by the pope: *Bulla / Ratificatio(n)is / data a / Pio PP. VII / Romae die 15. / Augusti / 1801.*
53.1×44.7 cm. Inv. 33 393; MV 2573

Standing out against a landscape in which we can make out the dome of Saint Peter's and the roofs of the Vatican Palace, as well as the facade of the Pantheon, Pope Pius VII presents the ratification bull to Cardinal Ettore Consalvi. The latter is holding the treaty signed in Paris. It was on the instigation of François Cacault (1743–1805), French plenipotentiary minister in Rome and one of the negotiators of the Concordat ratified in Paris on 15 July 1801 and approved in Rome on 15 August, that Wicar executed this drawing. Almost at the same time Cacault asked Wicar for a painting on the same subject (Castel Gandolfo, Pontifical Villa). The diplomat wished to perpetuate the happy outcome of the negotiation that restored religious peace in France. In January 1803 the drawing, which was not entirely completed, was presented on the occasion of a reception Cacault held in honour of four French prelates who had been raised to the cardinalate. On 2 February 1803 Cacault wrote to Talleyrand, Minister of Foreign Affairs, to tell him of the high quality of the work, "the ne plus ultra of draughtsmanship" according to him, outstanding for the likeness of the portraits "done from life", while suggesting an engraving be made after it (it would be executed by Lefèvre-Marchand, with a dedication to the First Consul). In view of the solemn character of the commission, and because he had to give some evidence of his return to better sentiments, Wicar took special care in executing his drawing, using close-set hatching to model the figures and architectural background with the greatest accuracy. Helped by Cacault, who had obtained for him the loan of several accessories, Wicar took care to render them down to the smallest detail.
Prov.: Given to Bonaparte by Monsignor Doria, Papal Legate, in late February 1803; Entered the Château of Versailles before 1855. SALMON, 2001, no. 77, repr.

BIBLIOGRAPHY

ALVIN, 1870
L. Alvin, *Fr. J. Navez, sa vie, ses œuvres et sa correspondance*. Brussels: 1870.

ANONYMOUS, 1896
"Les correspondants du peintre Fabre (1808–1834), lettres de Bertin aîné, Garnier, Férogio, Boguet, Mérimée père, Girodet-Trioson, Guérin, Gérard", *Nouvelle revue rétrospective*, January 1896, pp. 1–48.

BENOÎT, 1994
J. Benoît, *Philippe-Auguste Hennequin 1762–1833*. Paris: 1994.

BOTTINEAU, [1973], 1974
J. Bottineau, "Le décor de tableaux à la sacristie de l'ancienne abbatiale de Saint-Denis (1811–1823)", *Bulletin de la Société de l'histoire de l'art français*, year 1973. Paris: 1974, pp. 255–81.

CHAUSSARD, 1806
P. Chaussard, "Notice historique sur M. Drouais, élève de l'Académie royale de peinture", *Le Pausanias français, état des arts du dessin en France, à l'ouverture du XIX^e siècle, Salon de 1806*. Paris: 1806, pp. 337–53.

COEKELBERGHS and LOZE, 1985
D. Coekelberghs and P. Loze, *1770–1830, Autour du néo-classicisme en Belgique*. Exhib. cat. (Ixelles, Musée communal, 14 November 1985–8 February 1986). Ghent: 1985.

COEKELBERGHS and LOZE, 1987
D. Coekelberghs and P. Loze, *Autour de David. Le néo-classicisme en Belgique, 1770–1830*. Exhib. cat. (Paris, Pavillon des Arts, 1987–1988). Paris: 1987.

COEKELBERGHS, JACOBS and LOZE, 1999
D. Coekelberghs, A. Jacobs and P. Loze, *François-Joseph Navez (Charleroi 1787–Bruxelles 1869). La nostalgie de l'Italie*. Exhib. cat. (Charleroi, Musée des Beaux-Arts, La Chaux-de-Fonds, Musée, Coutances, Musée, 20 November 1999–15 October 2000). Ghent: 1999.

COUPIN, 1829
P.-A. Coupin, Œuvres posthumes de Girodet-Trioson, peintre d'histoire, suivies de sa correspondance, précédées d'une notice historique et mises en ordre par P.-A. Coupin. 2 vols. Paris: 1829.

CROW, 1989
T. Crow, "Girodet et David pendant la Révolution: un dialogue artistique et politique", in *David contre David*, proceedings of the symposium organised at the Musée du Louvre by the cultural service from 6 to 10 December 1989, under the direction of Régis Michel. Paris: 1993, vol. II, pp. 845–66.

DELACROIX, *Journal*
Journal de Eugène Delacroix, 1822–1863, published by André Joubin. 3 vols. Paris: 1931–1932, edition revised by Régis Labourdette. Paris: 1980, 2nd edition 1996.

DELÉCLUZE, 1983
E.-J. Delécluze, *Louis David, son école et son temps, souvenirs*. Paris: 1983, with preface and notes by J.-P. Mouilleseaux (1st ed. Paris: 1855).

DELESTRE, 1845
G. Delestre, *Gros, sa vie et ses ouvrages*. Paris: 1845.

DELESTRE, n.d.
G. Delestre, *Antoine-Jean Gros 1771–1835*. Paris: n.d.

FAURE, 1948
E. Faure, *Histoire de l'art. L'art moderne*. Paris: 1948.

GÉRARD, 1857
H. Gérard, *Œuvre du baron François Gérard, esquisses peintes, tableaux ébauchés, compositions dessinées, fac-similés, portraits à mi-corps et portraits en buste*. Vol. VI. Paris: 1857.

GÉRARD, 1867
H. Gérard, *Correspondance de François Gérard peintre d'histoire*

avec les artistes et les personnages célèbres de son temps, précédée d'une notice sur la vie et les œuvres de Gérard par M. Adolphe Viollet-le-Duc. Paris: 1867.

GUIFFREY and MARCEL, 1910

J. Guiffrey and P. Marcel, *Inventaire général des dessins du musée du Louvre et du musée de Versailles: École française.* Vol. V. Paris: 1910.

HAUTECOEUR, 1954

L. Hautecoeur, *Louis David.* Paris: 1954.

HOLMA, 1940

Kl. Holma, *David, son évolution et son style.* Paris: 1940.

LEVITINE, 1965

G. Levitine, "Quelques aspects peu connus de Girodet", *Gazette des Beaux-Arts,* April 1965, pp. 231–46.

LUGT, 1921, 1956

F. Lugt, *Les Marques de collections de dessins et d'estampes.* Amsterdam: 1921; *Supplément,* The Hague: 1956.

MICHEL, 1989

R. Michel, *Le Beau idéal.* Exhib. cat. (Paris, Musée du Louvre, Département des Arts graphiques, 17 October–31 December 1989). Paris: 1989.

MOLLARET and BROSSOLLET, 1968

H. Mollaret and J. Brossollet, "À propos des *Pestiférés de Jaffa* de A. J. Gros", *Jaarboek Antwerpen,* 1968, pp. 263–307.

MOREL D'ARLEUX

L.-M.-J. Morel d'Arleux, "Carnets manuscrits préparatoires à l'inventaire Napoléon, commencés en 1797". On deposit, Musée du Louvre, Département des Arts graphiques.

MOULIN, 1983

M. Moulin, "François Gérard peintre du 10 août 1792", *Gazette des Beaux-Arts,* May–June 1983, pp. 197–202.

RAMADE, 1985

Patrick Ramade, *Jean-Germain Drouais 1763–1788.* Exhib. cat. (Rennes, Musée des Beaux-Arts, 7 June–9 September 1985). Rennes: 1985.

ROSENBERG, 1995

P. Rosenberg, *Dessins français de la collection Prat, XVIIe–XVIIIe–XIXe siècles.* Exhib. cat. (Paris, Musée du Louvre, 26 April–24 July 1995). Paris: 1995.

SALMON, 2001

X. Salmon, *Chefs-d'œuvre du Cabinet d'arts graphiques du château de Versailles.* Exhib. cat. (Rouen, Musée des Beaux-Arts, 9 March–15 May 2001; Le Mans, Musée de la Ville, 22 June–2 September 2001). Azzano San Paolo: 2001.

SCAILLEREZ, 1992

C. Scaillerez, *François Ier et ses artistes dans les collections du Louvre.* Paris: 1992.

SÉRULLAZ and LACAMBRE, 1974

A. Sérullaz and J. Lacambre, *Le Néo-classicisme français. Dessins des musées de province.* Exhib. cat. (Paris, Grand Palais, 6 December 1974–10 February 1975). Paris: 1974.

SÉRULLAZ, 1972

Sérullaz, *Dessins français de 1750 à 1825 dans les collections du musée du Louvre. Le néo-classicisme.* Exhib. cat. (Paris, Musée du Louvre, Cabinet des Dessins, 14 June–2 October 1972). Paris: 1972.

SÉRULLAZ, 1984

A. Sérullaz, "Quelques dessins de Gérard pour le Virgile des frères Didot", *Antologia di Belle Arti,* 2, 1984, pp. 217–22.

SÉRULLAZ, 1986

A. Sérullaz, *Les mots dans le dessin.* Exhib. cat. (Paris, Musée du Louvre, Cabinet des Dessins, 19 June–29 September 1986). Paris: 1986.

SÉRULLAZ, 1999

A. Sérullaz, *Arte de las Academias Francia y México Siglos XVII–XIX.* Exhib. cat. (Mexico, Antiguo Colegio de San Ildefonso, October 1999–January 2000). Mexico City: 1999.

SÉRULLAZ, 2002

Sérullaz, "Acquisitions", *Revue du Louvre. La revue des musées de France,* 1, 2002, p. 98, no. 35, repr.

STENDHAL, 1972

Stendhal, *Salon de 1824,* Cercle du Bibliophile. Geneva: 1972, vol. XLVII, pp. 25–26.

TOUSSAINT, 1974

H. Toussaint, *Ossian.* Exhib. cat. (Paris, Grand Palais, 15 February–15 April 1974). Paris: 1974.

TRIPIER LE FRANC, 1880

J. Tripier Le Franc, *Histoire de la vie et de la mort du baron Gros, le grand peintre, rédigée sur de nouveaux documents et d'après des souvenirs inédits.* Paris: 1880.

WAKEFIELD, 1978

Wakefield, "Chateaubriand's 'Atala' as a Source of Inspiration in Nineteenth-Century Art", *The Burlington Magazine* 210, no. 898, January 1978, pp. 13–22.

WILDENSTEIN, 1973

D. and G. Wildenstein, *Documents complémentaires au catalogue de l'œuvre de Louis David.* Paris: 1973.

Photographic Credits

RMN/Michèle Bellot: nos 35, 40, 41, 43, 46, 47;
RMN/Jean Gilles Berizzi: nos 5, 38, 42, 44, 49; RMN/Gérard Blot: cover, nos 17, 31, 32, 37, 50;
RMN/Thierry Le Mage: nos 1–4, 6–13, 15, 16, 18–29, 33, 34, 36, 39, 45, 48;
RMN/Thierry Ollivier: nos 14, 30;
© PMVP/Lifermann: p. 2.

Paper
This book is printed on Satimat naturel 170 g;
cover: ArjoWiggins Impressions Keaykolour Nature Schiste 250 g

Colour Separation
Cross Media Network, Milan

Printed August 2005
by Arti Grafiche Bianca & Volta, Truccazzano, Milan
for the Musée du Louvre, Paris, and for 5 Continents Editions, Milan